BASEBALL
IN
RICHMOND

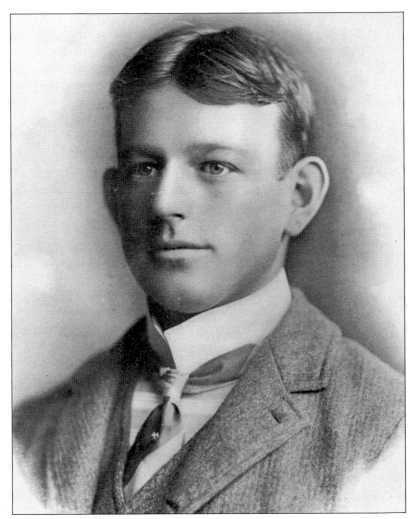

"HAPPY JACK" CHESBRO. "Happy Jack" twirled for the Richmond Johnnie Rebs of the Atlantic League from 1897 to 1899. Possibly the greatest pitcher to ever ascend to the pitchers mound in Richmond, Jack went on to excel in the major leagues. His 41 wins in the season of 1904 still stand as the record for most victories in modern-day baseball. He was enshrined in Cooperstown in 1948.

FRONT COVER: This is a rare 1897 studio cabinet photograph of Jack Chesbro in his Richmond wools.

COVER BACKGROUND: Pictured are the 1897 Richmond Johnnie Rebs, who featured future major league stars Jack Chesbro, Sam Leever, and Kid Elberfeld.

BACK COVER: Former Richmond Braves manager Brian Snitker takes time before a game at the Diamond to sign baseballs for Austin and Colt Germani.

BASEBALL
IN
RICHMOND

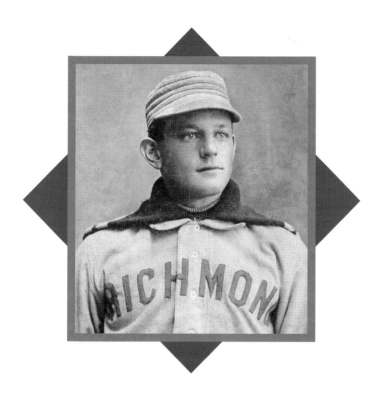

Ron Pomfrey

ARCADIA
PUBLISHING

Published by Arcadia Publishing
Charleston, South Carolina

Printed in the United States of America

Library of Congress Catalog Card Number: 2007943240

For all general information contact Arcadia Publishing at:
Telephone 843-853-2070
Fax 843-853-0044
E-mail sales@arcadiapublishing.com
For customer service and orders:
Toll-Free 1-888-313-2665

Visit us on the Internet at www.arcadiapublishing.com

This book is dedicated to my mother, Marie (Dolly) Pomfrey,
whose encouragement and positive attitude have been an example for all.

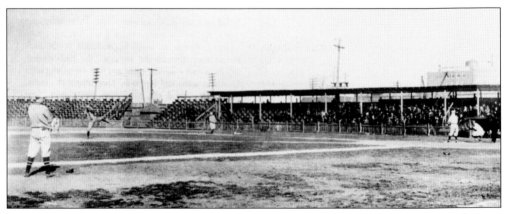

BROAD STREET PARK. The home playing field for the 1908 Richmond Lawmakers was located between Allen and Lombardy Streets. With fans outnumbering the seats, the cranks were often allowed to stand or sit along the outfield fence.

CONTENTS

ACKNOWLEDGMENTS

In the game of baseball, the pitcher is only successful if he has a strong supporting cast of team members. This pitcher wishes to express his profound gratitude to the following individuals who have contributed to this project with their support, encouragement, baseball memories, pictures, and artifacts: Sam Ayoub for his friendship and encouragement; Tom West for sharing his experiences with the Richmond Colts; Ed Stephens and Dot "Sunflower" Stephens for the many pepper games; George Stanford, George Tinker, Buncie Colgin, Lou Martin, and Andy McCutcheon for sharing their knowledge and artifacts; the Mechanicsville Drug Store Breakfast Bunch, who always have an ear for my baseball stories; Debbie Ring-Ashworth for her assistance with the "King's English;" Rich Wooddy and the 1957 Mechanicsville Jets; my children, Ronnie, Ginger, Chris, Gilbert, and Vicki, who keep me on my toes: "Momma D," who always has a smile to share; sister Sharon, who is an inspiration to all; and "Boo," who accepts all my imperfections and still likes me. Very special thanks go to the kindest, sweetest person I've ever known, my wife, Sandy, for without her patience, encouragement, and constant prodding, this book would not be possible or complete.

Unless noted, all pictures are from the personal collection of the author, Ron Pomfrey.

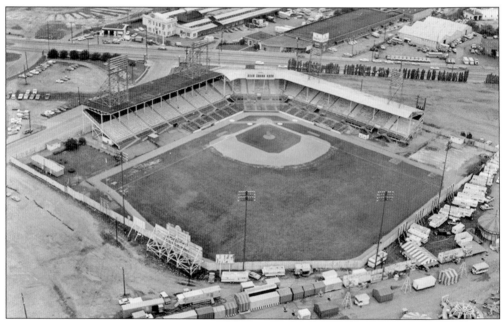

PARKER FIELD. Pictured above is a rare bird's-eye view of the fabled Parker Field on the Boulevard. Baseball opened for business here on April 8, 1954, when the Richmond Virginians played host to the world champion New York Yankees.

INTRODUCTION

The original purpose of composing this book was to share with the readers some of the history of Richmond baseball and the characters that laid the foundation for the game in this city by the river. Baseball in Richmond has been an integral part of the community since it was first introduced to the game following the War of Northern Aggression. The Army of the North, who occupied the fair city, brought the game into fashion with Richmonders in the late 1860s. The love of the game of baseball was said to spread like cholera through the 1870s. There were numerous organized teams called the Nines scattered throughout the Richmond community. Taking on names like the Atlantics, Mutuals, Spotswood, Pastime, and the Richmonds, these teams graced the many sandlots of the city. The year 1882 saw the birth of what could be called the first "professional" baseball in Richmond, when shoe-shop manufacturer Henry C. Boschen brought in players and paid them money to perform their skills for his Shoe Shop Team.

Throughout the process of assembling this book and carefully selecting the images to be displayed, I continually found myself drifting back to many of the fond memories I had relating to the game of baseball. There was my dad taking me to Sears and Roebuck to purchase my very first baseball glove, a Bob Feller model J. C. Higgins glove; Mr. Dart piling a group of eight boys into his 1950 Ford and taking us to Highland Park to play a group of locals; watching my mom meticulously hand-sew letters onto my first baseball cap; placing bubblegum cards in my bike spokes to make that fabulous sound of a roaring motorcycle; trading a 1956 Mickey Mantle baseball card for a Nellie Fox; buying my first baseball bat from Western Auto Hardware and proceeding to crack it my first time at bat; Ed Stephens honing my skills in his backyard with numerous games of pepper; night Wiffle ball games in the Wooddys' backyard; saddle-soaping my new glove and tying a ball in it to form the pocket; Wirt Jones, our little league coach, taking our team to Baltimore to see the Orioles play; my parents allowing me to miss school to see the Richmond Vees play the New York Yankees; hammering nails into the handle of a cracked bat, then taping over them to make the bat good as new; playing a pick-up baseball game on a hot summer's afternoon, using rocks as bases; standing outside the old Parker Field clubhouse on Sunday afternoons getting autographs of Richmond Vees players; seeing Roger Maris hit a home run at old Griffith Stadium in the season of 1961; and hiding a case of the measles from my mom so I could go see Ted Williams and the Red Sox play the Vees at Parker Field.

These are just a few of the baseball memories that composing this book spurred in me. Hopefully, as you peruse these pages, fond memories of your baseball past will surface. I know for me these were when times seemed much easier and life's pace was much slower. Take the time to share some baseball memories with your children or grandchildren, and don't forget to take a kid to a ballgame; it may be the best thing you ever did for yourself.

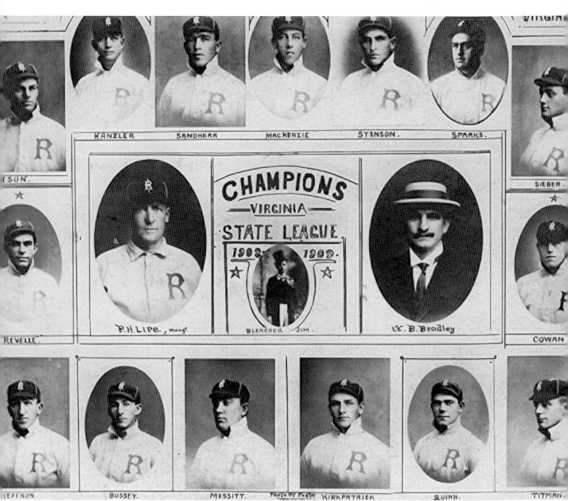

RICHMOND LAWMAKERS, 1908. Perhaps the greatest baseball team in Richmond's storied past, this group of hard-nosed ballplayers won the Virginia State League Championship in the 1908 season. The cranks came out in masses, averaging over 5,300 passing through the turnstiles at each home game. The Lawmakers outdrew the likes of major league teams like the New York Yankees, the Brooklyn Dodgers, and the Boston Braves. A Labor Day doubleheader against Danville brought 10,000 fans to the morning game, and 15,000 viewed the afternoon contest. The Lawmakers finished this championship season with 87 victories and a mere 42 losses.

FIRST INNING

THE NINES

RICHMOND LAWMAKERS, 1908

The season of 1908, Richmond baseball is wild,
For over 400,000 fans passed through the turnstile.
Owner Bradley brings in Lipe, Richmond baseball not a lark,
To manage our Lawmakers at old Broad Street Baseball Park.
Lipe quickly took charge, making many player moves.
Season began with a parade, led by Richmond Light Infantry Blues.
The first game is a rainout; Mr. Sun shows not a ray,
So the team, with shiny new uniforms, opens April 2, Easter Monday.
10,000 cranks hoot and holler, from the game's early beginning.
Revelle tames the Highlanders, but it takes 10 innings.
The team drops to third place, the fans are in a frenzy,
So Lipe goes out and acquires catcher Messitt and pitcher McKenzie.
With Danville in this pennant race, Lipe's men now must win.
He purchases a hitter, Stinson; two days later, pitcher Quinn.
The fans keep coming, cheering the Lawmakers, what a thrill!
Bleacher Jim is their leader, 300 take the train to Danville.
Richmond keeps a' winning, at an awesome percentage pace,
But still can't shake Tobacconists, determined to make a race.
Labor Day, Danville in town, winner we'll know soon;
Two games to play, one in the morn, the other afternoon.
25,000 fans pack the park to see the games be won.
Richmond wins the first 2-0, the second game tied one to one.
Oh, what a year for players and fans, they lit the city's lamps,
The Lawmakers won 87 lost 42, Virginia State League Champs!

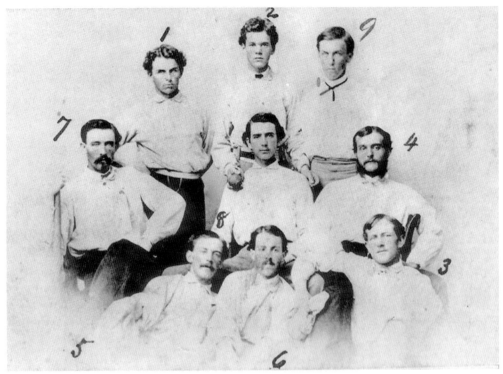

THE FIRST NINE OF RICHMOND BASEBALL. Posing here with the sphere of horsehide and the willow war-club is a contingent known as Richmond's First Nine Baseball club. Believed to be from the late 1860s, this team of dapperly outfitted young men, featured by number, are 1) Baird, 2) Weisiger, 3) Glazebrook, 4) Jim Tyler, 5) W. Taylor, 6) McFarlane, 7) Chockley, 8) Morton, and 9) Sam Taylor.

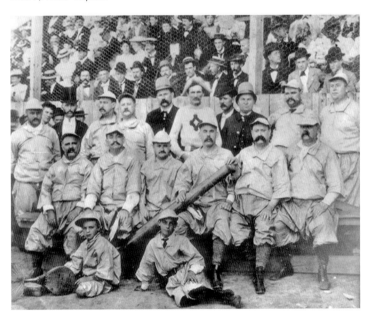

RICHMOND LITTLE BILLIES. This group of nines known as the Little Billies was composed primarily of Richmond policemen, a photogenic group of mustachioed defenders of the city gates, and dressed in some of the finest bloomer-style uniforms. The gentleman in the top hat, standing in the left rear, is the umpire.

FIRST INNING: THE NINES

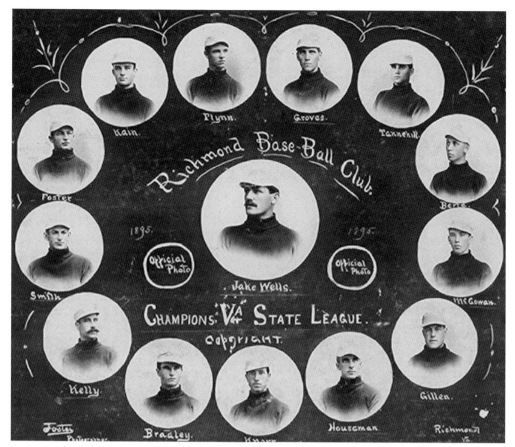

RICHMOND BLUEBIRDS, VIRGINIA STATE LEAGUE CHAMPIONS OF 1895. Heroes and legends were born in this championship season of 1895 for the Richmond Bluebirds. One hero was Jesse "Powder" Tannehill, who on September 8 tossed a no-hitter against the Roanoke Goats, clinching the pennant for the Bluebirds. Brought in to mold this flock of talent was local favorite Jake Wells, the manager who also caught and played first base. "Barley" Kain wielded a wicked wand as a slugsmith, and "Red" Foster proudly wore the tools of ignorance as catcher. Groves, Bradley, and Smith were superb outfield grazers, while Houseman and Berte were the Hoovers of the infield garden.

JUNE 6, 1888, HANOVER ACADEMY BASEBALL TEAM. Located on the outskirts of the city of Richmond in Hanover County, this academy was founded in 1859 by Col. Lewis Minor Coleman to prepare boys for the University of Virginia. From left to right are (first row) Heywood Hunter, Allen Talbott, Robert Pritlow, and C. Bland Payne; (second row) Phil Cooke, Edward McGavoch, Howard Shields, Max Barton, and Hatley Norton.

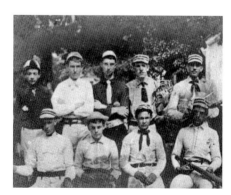

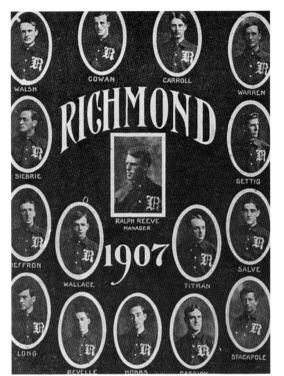

RICHMOND LAWMAKERS, 1907. The aggregation of ballplayers for the 1907 Richmond club included a mixture of seasoned veterans and untested kindergartners. Starting the season at a slow pace, team owner William Bradley made significant changes by mid-season. Manager Charlie Schaffer was sent to pasture and replaced by player manager Ralph Reeve, their shortstop. The club also obtained pitcher Robert "Dutch" Revelle at mid-season from the Portsmouth club. Outfielders included Bill Heffron, "Handsome" Guy Titman, and "Bonehead" Bobby Wallace. Doc Sebrie covered the keystone sack with Gus Salve the heaver. The Lawmakers ended the mediocre season with 62 wins and 62 losses.

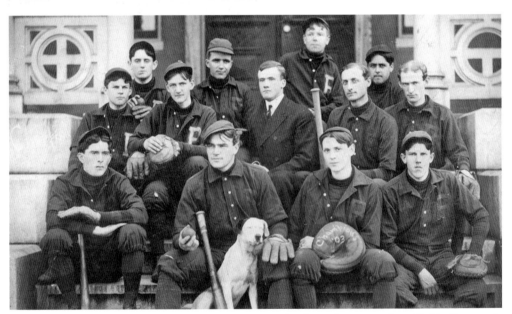

RICHMOND COLLEGE CHAMPIONS 1903. Stepping back to the time when Teddy Roosevelt was president of the United States, pictured here is a group of fine fencebusters whose facial expressions show their fierce competitive spirit. The champion Richmond College baseball team of 1903 played the likes of Randolph-Macon, William and Mary, Hampden-Sydney, and Virginia Polytechnic Institute.

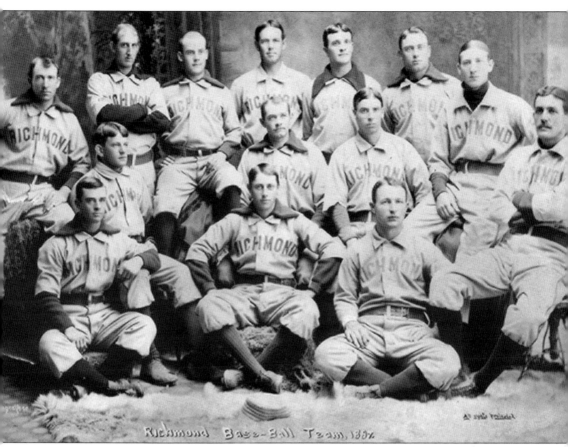

Richmond Base-Ball Team, 1897.

THE JOHNNIE REBS OF 1897. Joining a much stronger Atlantic League for the 1897 season, the Richmond Baseball Club started out as Bluebirds and ended up as Giants. For the majority of the season, they were known as the Johnnie Rebs. Jake Wells captained the ship, with Barley Kain patrolling right field and Red Foster a holdover as catcher, while Stuart, McDonald, and Hargrove handled things up the center of the garden. The heart of the Johnnie Rebs, however, was pumped by three future major-leaguers, Jack Chesbro, Sam Leever, and Norman Elberfeld. Chesbro's star was just beginning to shine, but he showed glimpses of his future Hall of Fame credentials, winning 16 games. Leever, a starboard slinger, honed his pitching skills, which led to a 12-year stay with the Pittsburgh Pirates. Elberfeld, the kid of the group, manned the hot corner at third base and became legendary for his feisty, firebrand style of play. Manager Wells was quoted in the *Richmond Dispatch*: "I want to assure the people that the team's trouble on the recent road trip was caused by lack of hitting, and not by bad hours or liquor."

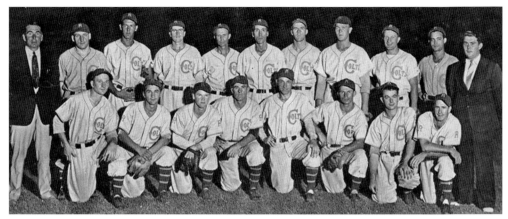

RICHMOND COLTS, 1938. New manager and former Boston Braves outfielder Lance Richbourg led this scrappy group of ballplayers. Featuring the league's most prolific hitters, the Colts showcased six .300 stickmen, with their "king of swat" being Norman "Babe" Young, who clipped Piedmont pitchers with a .352 batting average and 17 home runs. Sixteen-game winner John Leonardo, the team's "most popular player," distinguished the moundsmen. From left to right are (first row) Joe Bokina, George Kapura, Jim Carlin, Larry Kinzer, manager Lance Richbourg, Jim Gruzdis, Issy Katzen, and Jim Trexler; (second row) owner Eddie Moore, Clary Anderson, Babe Young, Austin McGee, George Ferrell, John Leonardo, Jim Sheehan, Harry Shuman, Steve Kuk, Tom de la Cruz, and announcer Peco Gleason.

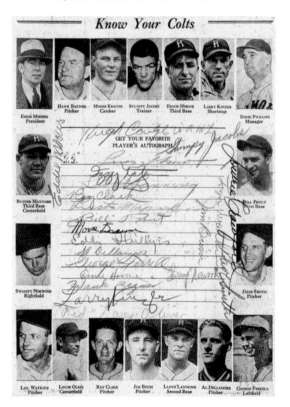

RICHMOND COLTS, 1940 PIEDMONT LEAGUE CHAMPIONS. Ed Phillips and his boys ran away with Piedmont League pennant in the sultry season of 1940. These individual pictures and autographs are of one of the most talent-packed teams in Richmond Colts history. The league's Most Valuable Player, leftfielder Buster Maynard, led the Colts. Maynard batted .337 with 30 home runs. First baseman Bill Prout had a league-leading 103 RBIs, while third-baseman Ernie Horne stroked the pill to a .336 average. Twenty-game winners Lynn Watkins and Henry Banzer led the moundsmen.

FIRST INNING: THE NINES

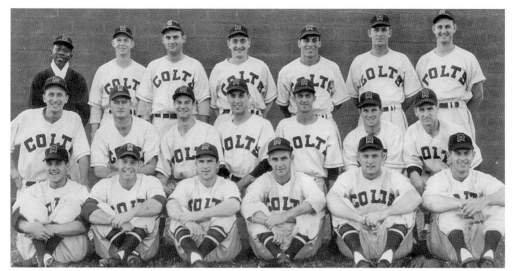

RICHMOND COLTS: PLAYOFF BOUND, 1949. In this team photograph of the 1949 Richmond Colts, the players had reason to beam these bright smiles, for they earned a spot in the Piedmont League playoffs with a third-place finish, winning 71 and losing 68. A new player-manager, Vinnie Smith, led the squad. The team's batting leader was right fielder Ralph Davis, who stroked the sphere to a .308 batting average, with the moundsmen led by twirler Jim Federico, who posted 16 victories.

RICHMOND DYERS: 1946 INTERCITY LEAGUE CHAMPIONS. Bragging rights for an intercity championship have been vied for throughout the history of baseball in Richmond. Pictured here are the champions of the 1946 Intercity League, the Richmond Dyers, an impressive group of amateur ballplayers who perennially made short work of crosstown foes. The team was led by slick-fielding second-baseman Billy McCann; lefty Weenie Miller, who anchored down first base; and potent hitter Buncie Colgin. From left to right are (first row) Tony Miller, Weenie Miller, Billy McCann, unidentified, Buncie Colgin, Thermy Throckmorton, Bus Gioveantti, and Bobby Harris; (second row) Al Torellis, Hershel Fornash, Tom Inge, Minor Boos, Ira Leeber, Ed Hughes, Coney Williams, Al Weaver, and Sonny Wholey.

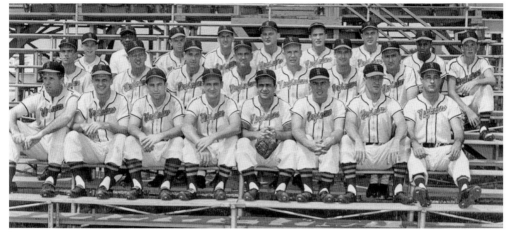

RICHMOND VEES, 1955. Posing in the grandstands of old Parker Field is this aggregation of salty veterans and a like amount of rookie pineapples, which made up the 1955 Richmond Vees. Led by their shepherd, Luke Appling, and sprinkled with ex-major leaguers Bill Voiselle, Vern Bickford, Dick Starr, former National League MVP Jim Konstanty, and newcomers Bobby Richardson, Eddie Kasko, and Allen Barbee, the Vees finished the 1955 season as cellar champions. Former Negro League star Butch McCord manned first base.

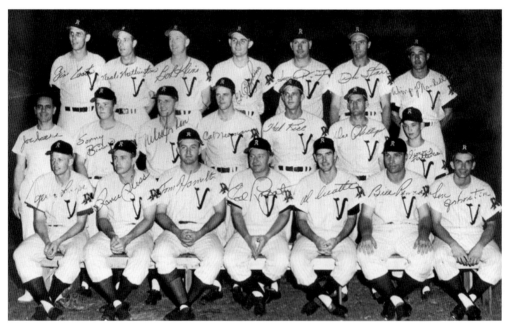

DONNING THE PINSTRIPES IN 1956. The 1956 Richmond Virginians sported new spangles and colors for the 1956 season. Becoming an official affiliate of the New York Yankees, the Vees wore the pinstripes made popular by the Bronx Bombers. "Steady Eddie" Lopat was named to develop the talents of this Richmond contingent. Al Cicotte, who posted 15 victories, led their mound staff. The stickmen had muscleman outfielder Bill Renna leading the way while smacking 20 dingers. The team appeared to turn the corner in 1956 with a respectable fifth-place finish.

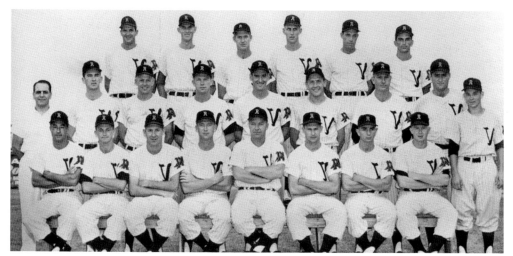

PLAYOFF BOUND IN 1957. The 1957 Richmond Virginians distinguished themselves as contenders in the International League. They provided the diamond bugs with excitement and thrills galore. With the leadership skills of manager Eddie Lopat, stalwart pitchers Jim Coates and Bill Bethel, the bats of Harry Chiti and John Jaciuk, and all-around play of Lennie Johnston, Jerry Lumpe, and Gerry Thomas, the Vees finished in third place, making the International League playoffs for the first time. The local fans came through the turnstiles in droves and set a Vees attendance record of 258,861.

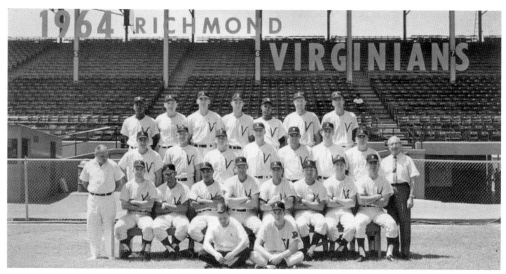

SAY IT AIN'T SO, 1964. This was a red-letter year in the Richmond baseball annals, as the shock and bitterness at learning the Richmond Vees would be moved to Toledo, Ohio, prevailed throughout the baseball community. After the uneventful season of 1964, team owner Romeo Champagne moved the team to Ohio. The beloved Richmond Vees would now become the Toledo Mud Hens, and die-hard bleacherites cried out, "Say it ain't so!" Future Yankee pitching great Mel Sottlemyre led the 1964 Vees with 13 victories before his mid-season call-up to the big show. Former major-leaguer Art Lopez, tattering the sphere at a .315 clip, led the batsmen.

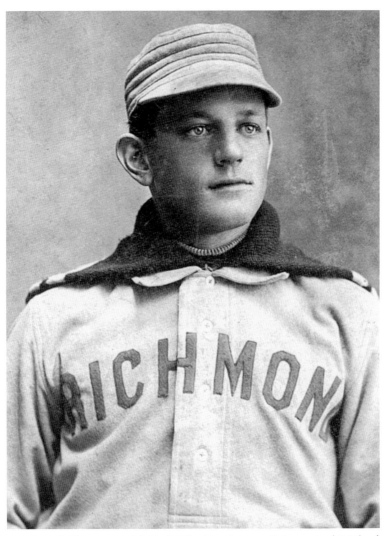

JOHN "HAPPY JACK" CHESBRO, 1897–1899. Simply put, "Happy Jack" Chesbro was the Michelangelo of pitchers in Richmond, Virginia. Chesbro first donned the uniform of the Johnnie Rebs in 1897, twirling for the Richmond club of the Atlantic League. He won 56 games during his three-year stay in Richmond and led the team to the pinnacle of the Atlantic League in 1899. It was said of Chesbro that he could throw a lamb chop past a wolf, which was the ultimate compliment to a heaver of the day. In the later half of the 1899 season, Happy Jack was sold to the National League's Pittsburgh Pirates, whom he proceeded to lead to their first pennants in 1901 and 1902. As a member of the New York Highlanders from 1903 to 1909, he continued amassing fabulous pitching statistics as the Highlanders' ace hurler. The season of 1904 saw Jack win 41 games while inducing many a batsman to carve nicks in the weather, striking out 239. This 41-win season is still a record in the annals of modern-day baseball. Jack's major-league career produced 199 victories in 11 seasons, which led to his enshrinement in the Baseball Hall of Fame in 1948. His ability to manipulate the sphere brought smiles and happiness to many of the diamond bugs who saw him twirl at the old Broad Street Park.

SECOND INNING

THE CHARACTERS

JACK, SAM, AND THE KID

The season of 1897, in the Atlantic League we'd stew.
Richmond had new players for the cranks in the stands to view.
What shall they be called, throughout this new ball year?
Was that "Bluebirds," "Johnnies," or "Giants," echoing in our ear?
A twirler in from Roanoke, we'd all get to know,
Some called him Happy Jack, better known as just Chesbro.
Toiled three years in Richmond, without much acclaim,
Then on to Pittsburgh, New York, and the Baseball Hall of Fame.
Let's not forget the other moundsman who helped stoke baseball fever,
The stoic Ol' Schoolmaster we knew as Sam Leever.
For only two seasons, with Richmond he did heave,
Next year with Pittsburgh, many a batter would he deceive.
Thirteen years as a Pirate, his pitching not subpar,
Ended with 194 victories, a true major league star.
And then with Cincinnati, did we ever make a deal!
In came a feisty infielder, known as Kid Elberfeld,
With a daring style of play, opposing players he disliked.
Poured raw whiskey on his wounds, from opponent's sharpened spikes.
Only one year with the Johnnies, but a major leaguer he would be,
Spent some time as a Detroit Tiger, managed the Yankees oh so briefly.
We didn't have Babe Ruth, Cobb, or Mickey Mantle,
But, oh how we loved these three stars from Richmond's baseball annals.

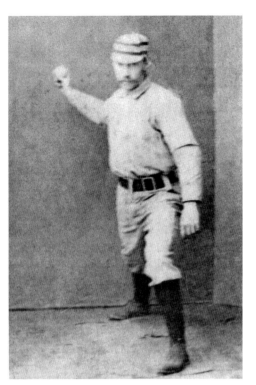

CHARLIE FERGUSON. Brought to Richmond by "Daddy" Boshen, Ferguson was one of the first players paid to play baseball and work in Boshen's shoe manufacturing plant. Charlie was quite the hurler of the twine and was known for throwing his in-shoots. Earmarked for the major leagues, Ferguson was sold to the Philadelphia club for the exorbitant figure of $3,000. He went on to win 99 games in four seasons with the Phillies. In the spring of 1888, a few days past his 25th birthday, he came down with typhoid fever and died prior to the start of the season.

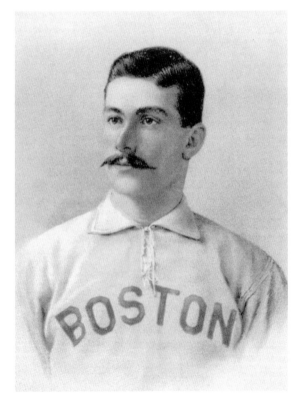

BILLY NASH. Born and bred in Richmond, Virginia, Nash had his start with Daddy Boschen's "shoe shop team" in the 1880s. He manned the hot corner for Richmond's first and only entry into major-league ball in 1884, as the Virginias of the American Association. Late in the 1885 season, Billy was sold to the Boston Beaneaters of the National League, where he played for 11 seasons. In 1896, he became player-manager of the Philadelphia Phillies.

SECOND INNING: THE CHARACTERS

"POP" TATE. A local baseball icon, Pop Tate was born in Richmond, Virginia, in 1860. Pop played on many of the local Richmond clubs, toiling behind the plate as the catcher. As a member of the Richmond Virginias of the Eastern League in 1885, Pop was destined for the majors. Late in the 1885 campaign, Pop was sold to the Boston Beaneaters, for whom he played three seasons. His career in the majors came to an end when his strong throwing arm became glassy and he returned to Richmond, where he played for the Richmond Crows in 1893. The Richmond club in 1926 renamed Island Park Tate Field in honor of one of Richmond's first baseball heroes.

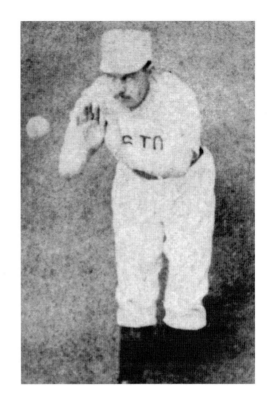

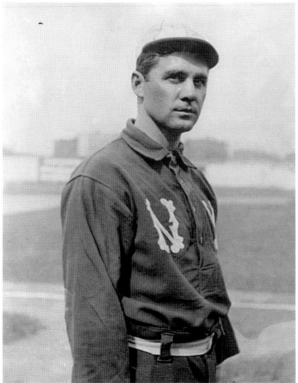

JESSE "POWDER" TANNEHILL. "Powder" delivered the pill for the Bluebirds in 1895 and 1896. On September 8, 1895, Tannehill pitched a no-hitter against the Roanoke Goats to clinch the Virginia State League championship for Richmond. He went on to excel in the major leagues, playing 13 seasons and pitching a no-hitter for the Red Sox in 1904.

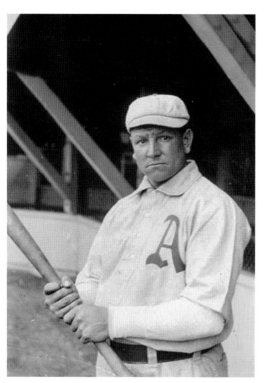

RALPH "SOCKS" SEYBOLD, RICHMOND BLUEBIRDS, 1898–1899. "Socks," a potent power-hitter, roamed the outfield for the Richmond club in 1898 and 1899. In August 1899, Seybold was sold to the Cincinnati major-league ball club. The next year, Connie Mack signed him for the Philadelphia Athletics, where he spent eight years. The 16 home runs Socks scored in 1902 set an American League record that lasted until 1919, when none other than Babe Ruth broke it. He returned for a brief stint with the Richmond Colts in 1912.

SAM "THE GOSHEN SCHOOLMASTER" LEEVER, 1897–1898. A true stalwart of the Richmond pitching staff, Leever twirled from the mound for the Bluebirds, the Johnnie Rebs, and the Giants in the seasons of 1897 and 1898. The *Richmond Dispatch* reported on September 15, 1897, "Pitcher Leever Does Good Work—He Pitched a Masterly Game and Was Invincible." Leever was signed by the Pittsburgh Pirates in 1899 and became a mainstay of their pitching staff. A right-handed pitcher of quiet ways, sober temperament, and a sharp breaking curveball, Sam amassed 194 major-league victories. In 1903, he led the National League in winning percentage and shutouts. Many feel Sam belongs in Cooperstown.

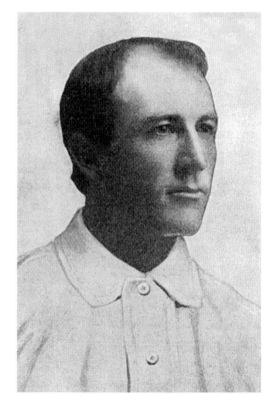

SECOND INNING: THE CHARACTERS

Norman "The Tabasco Kid" Elberfeld. Manager Jake Wells of the Johnnie Rebs brought in infielder Elberfeld from Cincinnati in 1897. Being small in stature (only 5 feet, 5 inches), Elberfeld made up for lack of height with his challenging style of play. It is said that he would dare opposing players to come in with their spikes high, and when he occasionally got cut by the opposing player, Elberfeld poured whiskey on his spike wounds to cauterize the wounds. The true sparkplug of the Johnnie Rebs, Kid was often the leadoff batter and played all the infield positions, even catching an occasional game. Kid adorned the ballyards of six different major-league teams during his 14-year career. He served a brief stint as manager of the New York Highlanders in 1908.

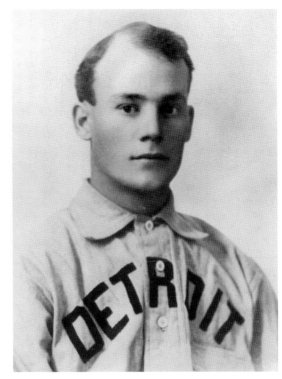

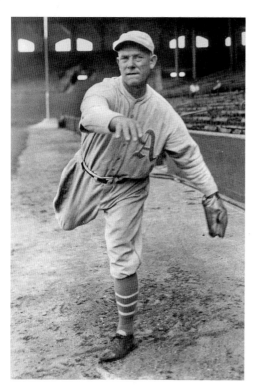

JACK QUINN, 1908. Quinn proudly wore the wool of the Richmond Lawmakers in 1908. A spitball twirler of the day, he helped the Lawmakers win the Virginia State League championship with 14 victories and no defeats. He was the only player from this legendary championship team to see playing time in the major leagues. Jack had 247 major-league wins pitching for eight different teams in three different leagues over 23 seasons.

ROBERT "DUTCH" REVELLE, 1908–1910. Immortalized as the hurler for Richmond's greatest all-time team, Dutch toed the rubber for the Richmond Lawmakers in 1908, 1909, and 1910. The Lawmakers won the Virginia State League championship in 1908, with Revelle leading the way with 26 pitching victories. Leading the circuit in strikeouts in 1908 and 1910—199 and 198 respectively—he also led the league in victories in 1909 with 29.

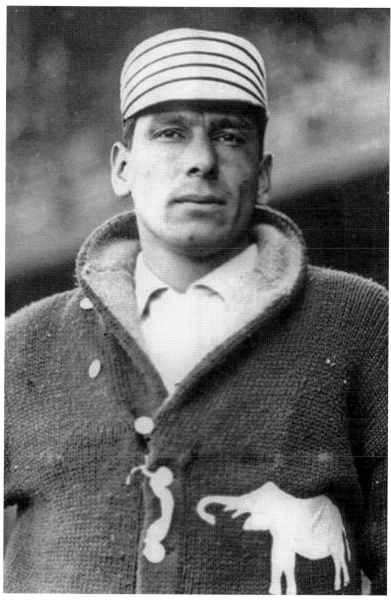

CHARLES "CHIEF" BENDER, 1919. Bender wore the wool for the Richmond Colts in 1919, being signed early in the season to be their player-manager. No greater addition to the team could have possibly been found, for Bender's contributions included 29 wins. As a pitcher, he led the Virginia League in strikeouts with 295, innings pitched with 324, and complete games with 31. He led the team to the championship of the second half of the season, which set the stage for a seven-game championship series between Bender's Tribe and the Petersburg Goobers. Bad blood developed between the two team's front offices, and the series never materialized. The Chief's major-league career spanned 16 seasons, primarily with Connie Mack's Philadelphia A's. He had 210 major-league victories, played in five different World Series, and was elected to the Baseball Hall of Fame in 1953.

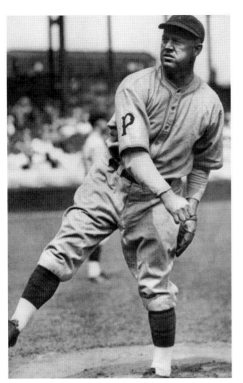

BURLEIGH "OL' STUBBLEBEARD" GRIMES, 1914. As a 21-year-old, Grimes toed the rubber for the Richmond Colts in 1914, winning 23 games. Known as an expectorant exhibitor, Grimes was truly destined for the Hall of Fame. He was only one of a handful of pitchers who was allowed to continue use of the spitball after it was banned in 1920. On the days Grimes was to pitch, he went without the razor, because the slippery elm he chewed to increase saliva irritated his skin. This growth of whiskers on his face led to his nickname, Ol' Stubblebeard. A belligerent hurler of the horsehide, his idea of an intentional pass was four pitches at the batter's head. His major-league career spanned some 19 years, totaling 270 victories while playing for eight different teams. In 1964, he was elected to the Baseball Hall of Fame.

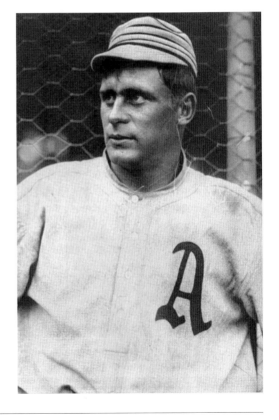

RUBE OLDRING, RICHMOND COLTS, 1922 AND 1926. One of Connie Mack's boys, Rube was the head maestro for the Richmond Colts in 1922 and 1926. His contingent of ballplayers in 1922 ended the season as cellar champions of the Virginia League. His ballplayers in 1926, led by Eddie Mooers and Stanley Stack, won the Virginia League championship with an 83-68 record. Rube's major-league career spanned 13 seasons, primarily with the Philadelphia Athletics.

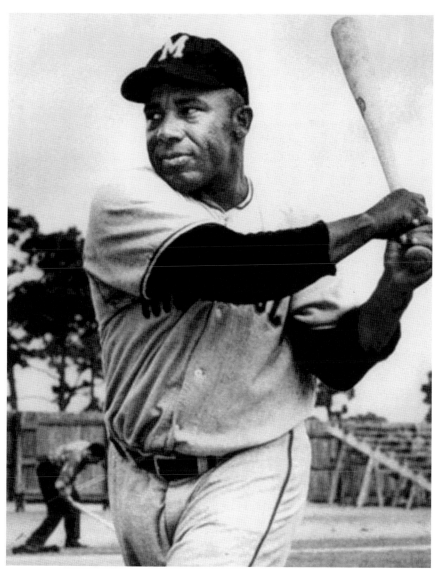

RAY DANDRIDGE, RICHMOND PARAMONTS, 1933. From a cornfield called Oakwood in Richmond's Church Hill community to the Baseball Hall of Fame, Ray Dandridge made a name for himself as a magician with both his glove and his bat. Upon seeing Ray work his magic on the playing field, the manager of the Detroit Stars of the Negro League would not leave Richmond until he had Dandridge signed to play for his team. The rest is history for the bowlegged third baseman from Richmond. It was said that a train could go through his bowlegs, but a baseball never did. It was well known that he was the best third baseman never to make the major leagues. Ray spent most of the 1940s playing in the Mexican League, where he received a higher paycheck. Upon his return to the Negro Leagues in the late 1940s, he was in the twilight of his career, but he caught the eye of the New York Giants, who signed him to their Triple-A club in Minneapolis. During his first year there, he won the league's MVP award. In 1987, Ray was inducted into the Baseball Hall of Fame.

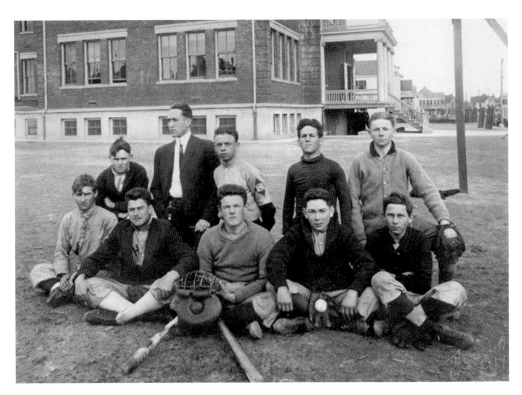

EDDIE MOOERS, "YOUTH AND WISDOM."
There can be no doubt that Eddie Mooers is one of the most influential people ever associated with baseball in Richmond, from his early years on the dirt and grass of Barton Heights School (pictured above, first row, second from right) to his professional playing days with the Richmond Colts at Tate Field to his team-ownership years and the building of the field at Norfolk and Roseneath Streets. A feisty infielder who was strong with the stick, he helped lead the Colts to Virginia League championships in 1925 and 1926.

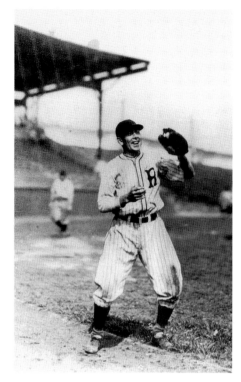

EDDIE MOOERS, "RICHMOND'S MR. BASEBALL." In 1933, Mooers purchased the Richmond Colts, and for the next 20 years, they were members of the Piedmont League. Somewhat of a maverick as an owner, Eddie (pictured above and below) was known to wheel and deal when purchasing and selling ballplayers, and as for changing managers, he would put George Steinbrenner to shame. The fans in Richmond owe much to Eddie Mooers, for without his enthusiasm, wisdom, and baseball savvy, baseball in Richmond may have wilted on the vine.

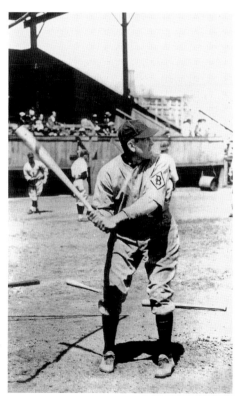

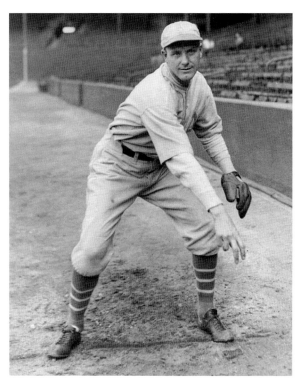

ED ROMMELL, 1935. Donning the home whites of the Richmond Colts, manager Ed Rommell brought home the pennant in 1935. The Colts ended the first half as cellar dwellers, but by the season's end, Rommell had them clicking on all cylinders as the Piedmont League champions. Rommell also toiled briefly on the mound, amassing six wins with his famous butterfly pitch. Known as the father of the modern knuckleball, he had hurled the sphere for some 13 years in the majors for Connie Mack's A's, winning 171 games. Once Ed decided to hang up his spikes as a player, he continued in baseball as a major-league umpire.

GEORGE FERRELL, 1935–1940. George distinguished himself as a 20-year minor-league veteran, six of which were with the Richmond Colts. He was the Piedmont League Most Valuable Player in 1935, hitting a hefty .377 with 25 taters. In 1936, George led the team to the league playoffs with a .335 batting average. Ferrell again led the Colts to the playoffs in 1937 and was voted to the Piedmont League All-Star Team. In 1939, George was recognized as the Most Valuable Colt. His tenure with the Colts came to a happy ending in 1940, when he helped the club win its first Piedmont League pennant.

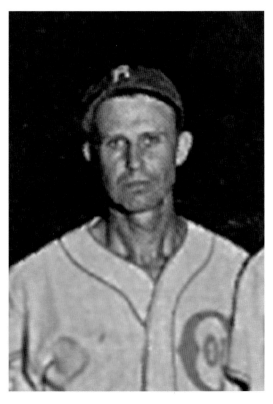

SECOND INNING: THE CHARACTERS

FRANK CARPIN, RICHMOND VEES, 1961, 1962, AND 1964. From the diamonds of Richmond's Benedictine High School to the dirt and grass of old Parker Field . . . Frank Carpin is seen here toeing the rubber for the Vees in 1964. The southpaw slinger wore the Richmond wools in 1961, 1962, and 1964, performing as both a starter and reliever. In 1964, he compiled his best stats with a 5-3 won/loss record and a 2.78 ERA. This performance helped pave the way to the "bigs," where he twirled for the Pirates in 1965 and for the Astros in 1966.

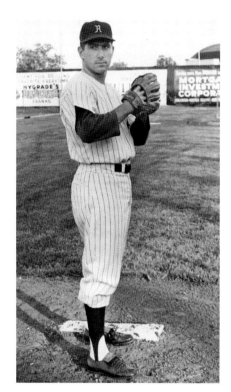

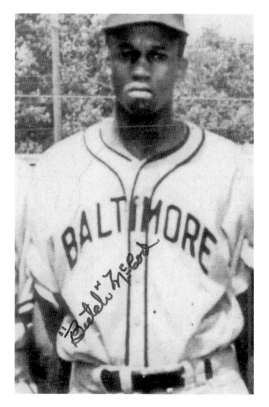

CLINTON "BUTCH" McCORD, RICHMOND VEES, 1955. A star first baseman in the Negro Leagues while playing for the Baltimore Elite Giants and the Chicago American Giants, Butch became the first black ballplayer for Richmond's Triple-A team, the Virginians. He spent the 1955 season as first baseman for the Vees, hitting a respectable .258 while leading the team in triples and RBIs. He recalled that one of his greatest thrills was "hitting a triple off Satchel Paige when I was 16."

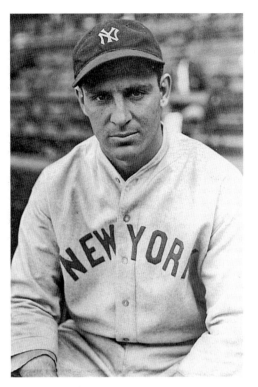

BEN CHAPMAN, 1942 AND 1944. As the player-manager for the Richmond Colts in 1942 and 1944, Ben marveled fans and foes, not only with his arm and the stick but also with his inability to control his temper. He played nearly every position and on occasion became a flipper of the sphere. Chapman batted an impressive .324 and was selected to the Piedmont League All-Star Team. He had many a run-in with the "men in blue." After sitting out a season, Ben came back as player-manager of the Colts in 1944. Near the end of the campaign, the Brooklyn Dodgers purchased him from the Colts for $10,000. With 15 seasons as a major-league player on six different teams, his lifetime batting average was .302. He helped the Yankees reach the World Series in 1932 and batted .294 in four World Series games. He was the first batter for the American League in the inaugural 1933 All-Star game.

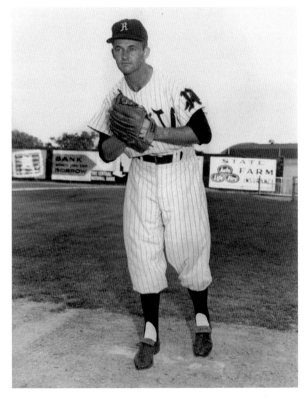

JOHNNY JAMES, RICHMOND VEES, 1957–1960. Contemplating the signal given by his catcher, Johnny is seen here on the warm-up mound of Parker Field. The premier relief pitcher for four seasons with the Vees, he had a team-leading ERA of 2.06 in 1959. A favorite of the cranks in the stands, Johnny earned a promotion in 1960 to the big top, where he posted a 5-1 record as a key reliever for the pennant-winning New York Yankees.

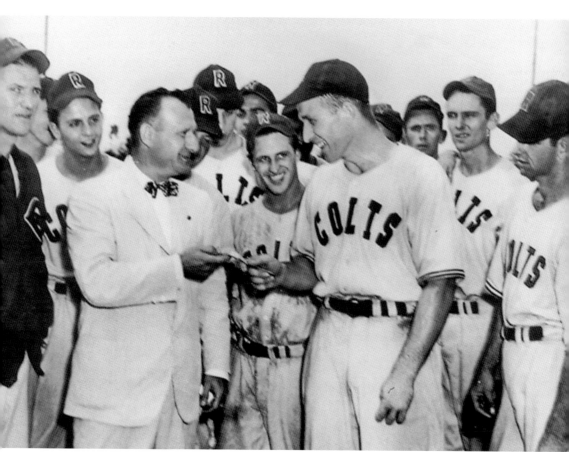

TOM WEST, "THE ORCHARDMAN OF OLD CHURCH," RICHMOND COLTS, 1945. On the field of play, Tom West had no peer during 1945. A local favorite of the ballites, Tom was known for his ability to wield a wicked bat. He annihilated many opposing pitchers with his stroking frozen ropes at the ballyard located at Roseneath and Norfolk Streets. His dominance at the plate for the Richmond Colts during 1945 led to a multitude of honors, including Piedmont League Most Valuable Player. He also led the league in batting with a .373 average, hits with 193, runs scored with 117, runs batted in with 101, and total bases with 271. Tom truly left his mark in the annals of Richmond baseball, but even greater than this was the manner in which he treated his fellow man.

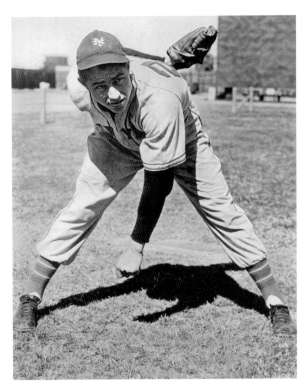

MONTE KENNEDY, "THE ACE OF AMELIA," 1942–1954. The only player to proudly wear the uniform of both the Piedmont League Richmond Colts (1942) and International League Richmond Vees (1954), Monte pitched parts of eight seasons for the New York Giants, with a career-high 12 victories in 1949. His wildness kept him in the soup, which eventually led to his ticket to the minors, but not until he had notched 42 wins with the Giants.

GARNETT BLAIR, 1953. An impressive speedballer, Blair made many a batter admire a third strike while twirling for the Homestead Grays of the Negro Leagues. Stopping in for just a cup of coffee with the Richmond Colts in 1953, he pitched in two games without a decision and was the second black ballplayer signed by team owner Eddie Mooers. Blair amassed winning seasons while hurling for the Homestead Grays during the 1940s playing alongside the Thunder Twins, Josh Gibson and Buck Leonard. He later played four years for the Richmond Giants of the Eastern Negro League.

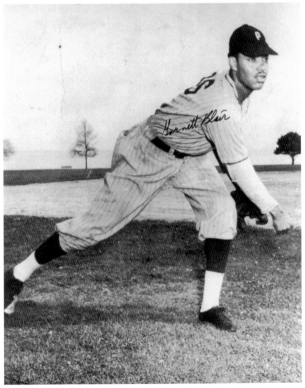

SECOND INNING: THE CHARACTERS

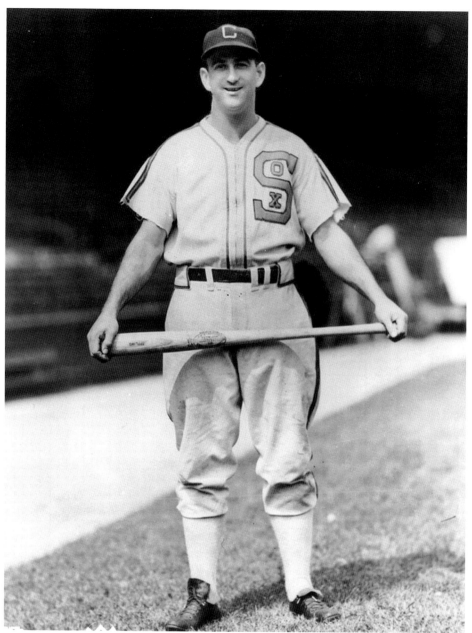

LUKE APPLING, "OLD ACHES AND PAINS," 1954–1955. Harry Seibold hired Appling in December 1953 to be the maestro of the newest entry in the International League, the Richmond Virginians. In 1954, the Vees won 60 and lost 94 to finish in seventh place. With Luke at the helm in 1955, the Vees were the cellar champions, winning only 58 games. Luke did have a legendary major-league career with the Chicago White Sox. He led the American League in batting in 1936, hitting an impressive .388, the first time ever for a White Sox player. The slick-fielding shortstop again won the batting crown in 1943. Voted an American League All-Star on eight occasions, he was inducted into baseball's glory circle in 1964.

BASEBALL IN RICHMOND

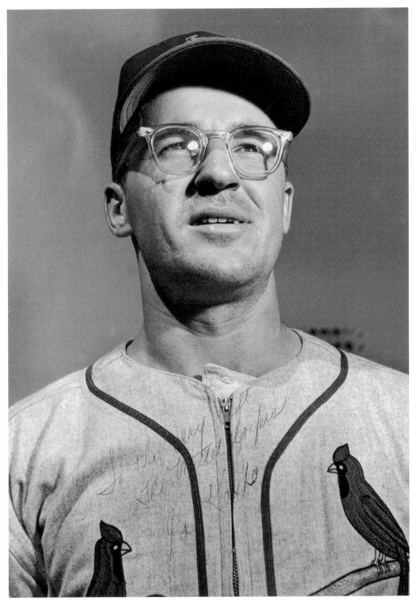

EDWARD "EDDIE" KASKO, 1954–1955. Truly a favorite of the turnstilers, Eddie wore the spikes of the Richmond Vees for 1954 and 1955. Known for his ability to swipe a hassock, he led the Vees in stolen bases in 1954 and 1955. Grooming himself with both the leather and the lumber during his tenure with the Vees, Eddie went on to become an International League All-Star in 1956 while playing for the Rochester Red Wings. He had a 10-year major-league career with four different teams—St. Louis, Cincinnati, Houston, and Boston. In 1961, Eddie was named the National League All-Star shortstop while leading the Cincinnati Reds to the pennant with his solid fielding and timely hitting. In the 1961 World Series against the Bronx Bombers, Eddie swung a potent bat, hitting .318. The season of 1970 saw the Boston Red Sox name Eddie as their field general. An ambassador for the game and a true gentleman, Eddie still resides in Richmond.

SECOND INNING: THE CHARACTERS

BOBBY RICHARDSON, RICHMOND VIRGINIANS, 1955. While only with the Vees for a brief stay during the 1955 season, Bobby held down the keystone sack for 25 games and batted .280. He is known for his fantastic playing career in the majors with the New York Yankees. Bobby was the 1960 World Series Most Valuable Player, batting .367 with 11 hits and a grand-slam home run. As a smooth-fielding second sacker, Bobby won five consecutive Gold Glove Awards from 1961 to 1965 and was voted to the American League All-Star team seven times.

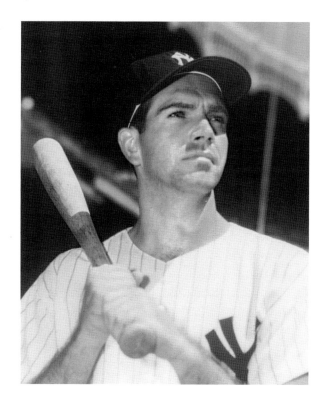

GERRY THOMAS, RICHMOND VIRGINIANS, 1957–1960 AND 1962. A premier swatsmith for the Vees during the late 1950s and early 1960s, Gerry was the only Richmond Vees player to lead the team in hitting for two consecutive seasons. In 1958, he played the timber to the tune of .292, and the following season he also had a team-leading batting average of .299. A bleacher favorite, Gerry also marveled the fans of old Parker Field with his arm and his glove from right field. Many a Richmond fan felt Gerry being anchored in the minors was truly a misjudgment of baseball talent.

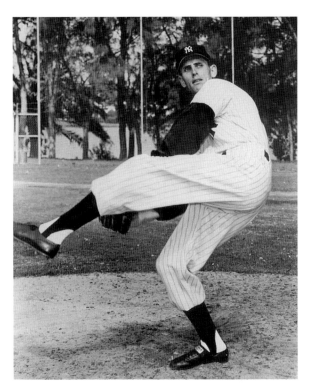

JIM COATES, RICHMOND VIRGINIANS, 1956–1958. Known as the "flamethrower from the Northern Neck," Jim toiled on the mound for the Vees from 1956 to 1958. Starting in the cork-popper of the 1957 season, he pitched a four-hit shutout against Rochester. For that season, Jim won 14 games and was selected to the International League All-Star Team. Jim is the Vees' all-time leader in innings pitched for a season, with 226 in 1957. Jim spent 1959 to 1962 with the New York Yankees, winning 37 games. He played in three different World Series, making six appearances.

DERON "THE PHENOM" JOHNSON, RICHMOND VIRGINIANS, 1958–1960. The Phenom had a knack for depositing the pill over the fences at old Parker Field. In his three seasons with Richmond, "Big D" had in consecutive years 27, 25, and 27 round-trippers. He holds the Vees' all-time RBI record of 103 in 1958. He was also voted to the International League All-Star Team in 1958. Destined for the major leagues, the New York press dubbed Johnson another Mickey Mantle, but he only played a short time for that powerhouse of a team in 1961 and was traded to Cincinnati. He played on eight different major-league teams, hitting 245 home runs in his 16-year career.

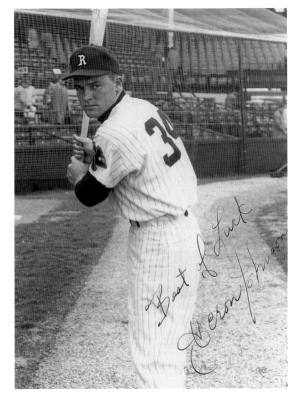

"STEADY EDDIE" LOPAT, 1956–1958.
Steady Eddie Lopat became the player-manager for the Richmond Vees in 1956, after closing out a storied pitching career with the New York Yankees. The wrong-armer had 166 major-league wins and played in five different World Series. Eddie was prolific with an assortment of slow breaking pitches thrown with cunning and accuracy. As a moundsman for the Vees in 1956, Eddie still had dominance with his slow moving Uncle Charlie and went on to post 11 wins.

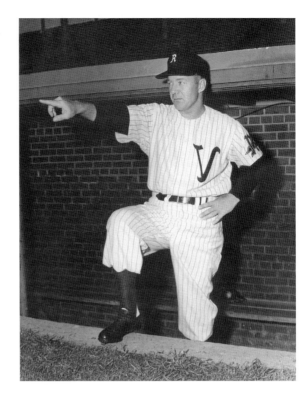

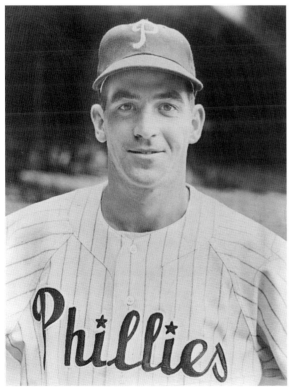

GRANVILLE "GRANNY" HAMNER, RICHMOND VIRGINIANS, 1960.
Growing up in the city of Richmond, Granny was destined for the major leagues, with his ability with the hickory and his handling of the leather. Breaking in with the Philadelphia Phillies in 1944 at the youthful age of 17, he spent parts of 17 years as a major-leaguer. Distinguishing himself around the keystone sack, Granny was an all-star as both a shortstop and second baseman. Hamner spent the 1960 season as a player-coach with the Richmond Vees. Honing his skills with Richmond as a knuckleballer led to his ticket back to the majors as a relief pitcher.

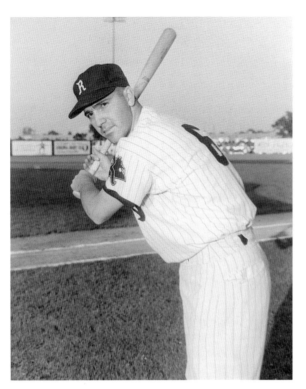

CLETIS "CLETE" BOYER, RICHMOND VIRGINIANS, 1958–1959. Noted for bringing the leather to the inner garden, Clete also carried a big stick to the dish during his days with the Vees. In 1958, he stroked 22 round-trippers, while hitting .284. From his shortstop position, he led the International League in double plays, putouts, and assists. During Clete's 16-year major-league career, he played for three different clubs but was primarily known for his Hoover-type play as a Yankee third-sacker. He played in five different World Series contests. Near the end of his career he became the first American to be traded to a Japanese League team, the Tayio Whales.

GENE ALLEY, ALL-STAR. A slick-fielding shortstop from Glen Allen, Virginia, Gene honed his skills with the leather on the Hogan's Brickyard of Hermitage High School. A bona fide major-leaguer, he had an illustrious 11-year career from 1962 to 1973 as a shortstop for the Pittsburgh Pirates. In his early years with the Pirates, Gene was a defensive standout. By the 1966 season, he had found his war-club and stroked the pill for an impressive .299 average. He quickly established himself as the premier shortstop in the National League, winning Gold Glove Awards in 1966 and 1967 and obtaining all-star status in 1967 and 1968. Even greater than his exploits on the diamond, Gene was thought of by the people who know him best as a true Virginia gentleman.

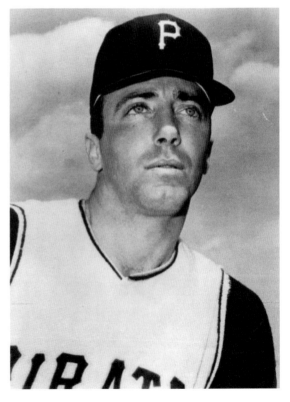

TOM TRESH, RICHMOND VIRGINIANS, 1961. Tom was a switch-hitting shortstop who won Rookie of the Year honors in the International League in 1961 while playing for the Vees. He also swung the stick for a team-leading .315 batting average that season and was named to the International League All-Star Team. This outstanding 1961 season won him a promotion to the Vees' parent team, the New York Yankees, for the 1962 season. As a Yankee, he won the American League Rookie of the Year Award in 1962, holding down the shortstop position. He was named to the American League All-Star Team in 1962 and 1963. In 1965, he won the American League Gold Glove Award. He played in three different World Series for the Yankees and was switched to the outfield in 1963.

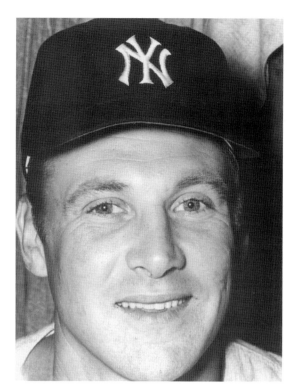

MEL STOTTLEMYRE, RICHMOND VIRGINIANS, 1963–1964. The northpaw ace of the Vees staff in 1963 and 1964, Mel was known for his unhitable sinker. This bread-and-butter pitch was his insurance in paving his way to the House that Ruth Built. In the 1964 season for the Vees, Mel had 13 victories and posted a 1.42 ERA, which still stands as a Richmond Vees record. He was also selected to the International League All-Star Team in 1964. During his 11-year career with the Yankees, he was considered the classy, reliable staff ace, winning 164 games in his unassuming manner.

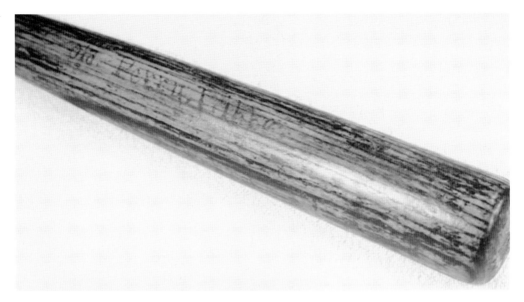

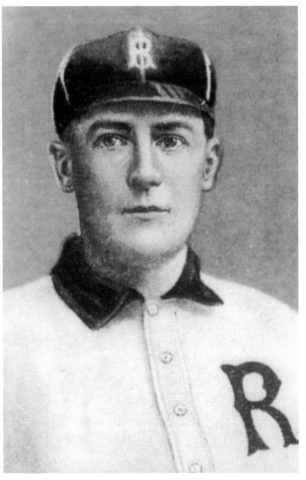

OLD PERRY LIPE: SIDE WRITTEN BAT. The vintage 34-inch war-club above was used by old Perry Lipe, the manager and third baseman for the 1908 Richmond Lawmakers. Side-written bats are among the most coveted bats, as they provide extreme provenance as to game use. During this period, players would return used, cracked bats to the Louisville Slugger plant along with a request to manufacture new bats to the same specifications. Once the mailed bat was delivered to the bat company, an employee identified the bat by writing the player's name in grease pencil on the bat barrel. This bat possesses the very legible grease-pencil name of Old Perry Lipe. The center brand marking is bold and distinct—J. F. Hillerich and Sons Company—with the dash-dot-dash above and below. This marking dates the bat to the dead ball era (1911–1915).

THIRD INNING

WAGON TONGUES
AND HORSEHIDES

THE MAJESTIC WAND

In days of yore, the times of ease,
The Majestic Wand, was carved from trees.
From the willow, oak, hickory, and ash,
Whittled to perfection, the horsehide it would smash.
The makers were many, seems the batter's best friend,
There was Spalding, Reach, Wright-Ditson, and Kren,
But the tool of choice, to give the fans a great thrill,
Was meticulously crafted from that factory in Louisville.
The styles there were many, the workmanship so fine.
If you wanted a skinny handle, you chose an Al Kaline.
Not for every batter, to many it was a pox,
Need a thicker handle, then pick up a Nellie Fox.
The knobs, oh so varied, the players they did groom.
There was the Hornsby, Ball & Knob, our favorite the Mushroom,
Cudgel, war club, timber, just names our bats have sung,
But in the days of ballyards past, just called the wagon tongue.

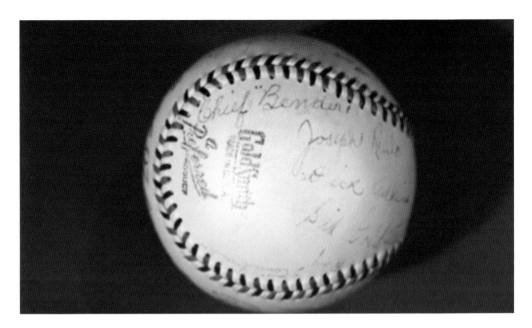

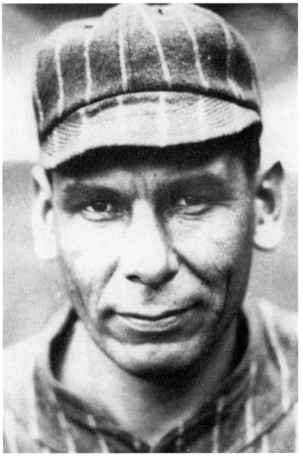

CHIEF BENDER AUTOGRAPHED BALL. A dominating pitcher years before the term enjoyed common usage, Chief Bender's accomplishments from the slab are simply astonishing. As manager and pitcher for the Richmond Colts in 1919, he amassed 29 wins as a pitcher while leading the Virginia League in strikeouts with 295. The creamy-toned, red-and-black-seamed Goldsmith baseball pictured above has bold "Virginia League Ray Ryan President" stamping. Any Bender-autographed ball is a scarce and desirable relic.

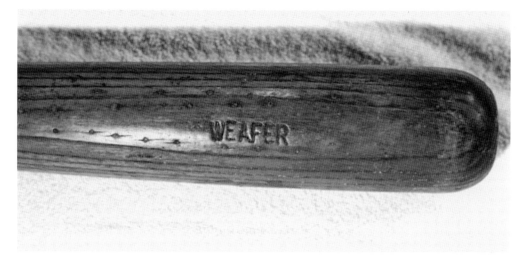

HAL WEAFER, 1921–1931 GAME-USED BAT. A hitsmith for the Richmond baseball club during the 1920s, Weafer led the Colts to the Virginia State League championship, winning three pennants and a share of the fourth. In 1925, he led the circuit in batting with a .391 average. Weafer's ability with his war-club is legendary. This pictured timber is 34.75 inches in length and features the Hillerich and Bradsby block lettering with "Weafer" stamped in the barrel end. This bat dates back to the 1921–1931 era and features numerous vintage nails for deadwood repair.

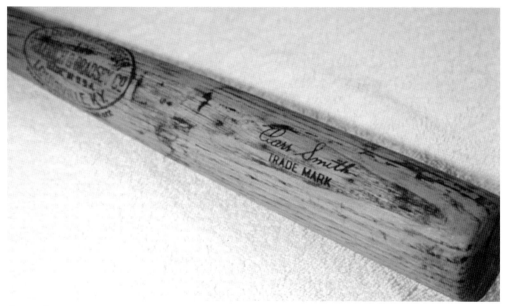

CARR SMITH, 1921–1931 GAME-USED BAT. Carr was a hitting legend in the Virginia State League. In 1923, Smith batted an astounding .418 for the Raleigh Nats of the Piedmont League. Smith played for Richmond of the Virginia League in 1920 and batted a respectable .310. In 1932, again wearing the Richmond wools in the Eastern League, he led the circuit with a .383 batting average and in 1933 stroked the pill for a .331 clip. This Carr Smith signature bat dates to the 1921–1931 era. The bat exhibits heavy game use, including ball and cleat marks.

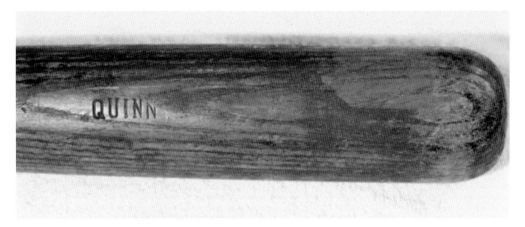

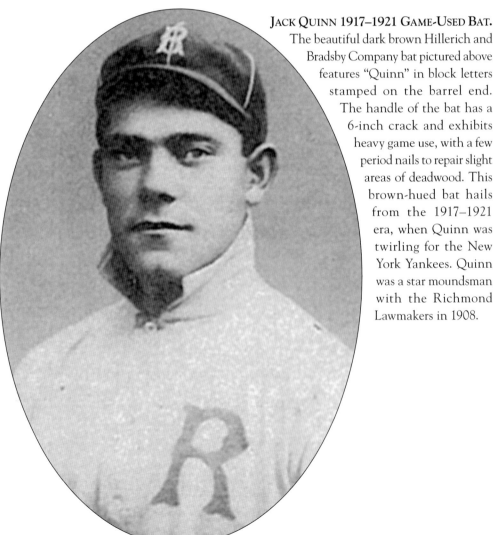

JACK QUINN 1917–1921 GAME-USED BAT.
The beautiful dark brown Hillerich and Bradsby Company bat pictured above features "Quinn" in block letters stamped on the barrel end. The handle of the bat has a 6-inch crack and exhibits heavy game use, with a few period nails to repair slight areas of deadwood. This brown-hued bat hails from the 1917–1921 era, when Quinn was twirling for the New York Yankees. Quinn was a star moundsman with the Richmond Lawmakers in 1908.

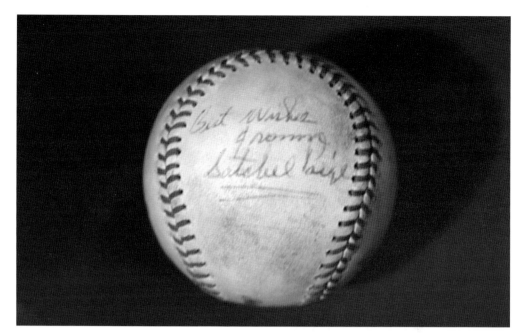

SATCHEL PAIGE SINGLE-SIGNED BALL. In his prime, no pitcher commanded the sphere like Satchel Paige. Those who witnessed his ascension to the mound proclaimed his unequaled dominance as a twirler. When finally granted the opportunity to pitch in the white major leagues in 1953, Paige still had enough left in that magical right arm to induce many a potent hitter to pound the air. Paige graced the grounds of Parker Field in 1958 while playing for the International League Miami Marlins. Seen above is an official International League ball autographed by the baseball hero and legend. On a side panel, Satchel placed his signature, along with the salutation "Best Wishes from."

BASEBALL IN RICHMOND

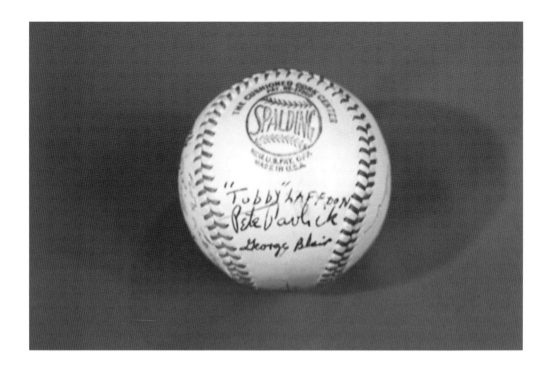

RICHMOND COLTS TEAM-SIGNED BALL, 1947. This 1947 Colts team signed ball displays 16 eye-popping signatures of Richmond players. The manufacturer's stamping on this official National League ball remains bold and distinct. This highly displayable sphere showcases the following team members: Tubby Laffon, Pete Pavlick, George Blair, John Ellis, Eddie Mooers, George Sumey, Emil Cabera, Cotton Bagwell, Raul Diaz, Al Tiederiam, John Travis, Bob Latsh, Bill Davies, Dick Wilbt, Len Morrison, and Bud Harstin.

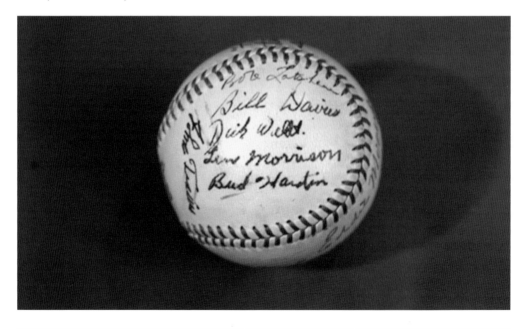

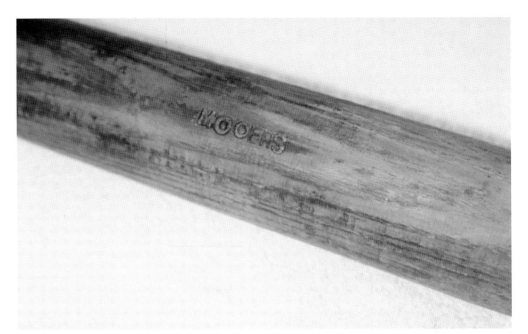

EDDIE MOOERS HILLERICH AND BRADSBY COMPANY SIDE-WRITTEN BAT, 1917–1921. Simply put, this is the most desirable early game-used bat brandished by Richmond's "Mr. Baseball," Eddie Mooers. Surely used on the sandlots of Richmond, Virginia, this timber dates to the years 1917–1921. The barrel end features a predominant, heavy, block-lettered "Mooers." Side writing in grease pencil is "Mooers 36 oz. Harris Flippen Co. Richmond VA." This 35.75-inch willow features the Hornsby style knob end.

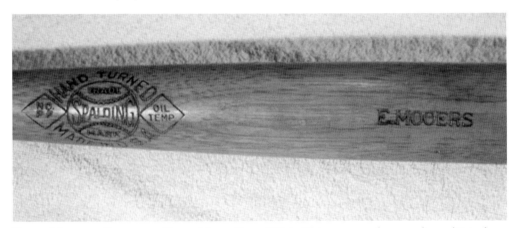

EDDIE MOOERS SPALDING GAME-USED BAT, 1931. This spectacular wooden relic is from Richmond's favorite, Eddie Mooers. Spalding made this Mooers magic wand, with the famous ball-diamond brand logo and "E. Mooers" in full block print on the barrel end. This lovely wood-grain bat is 34 inches in length and retains its original patina. Side written on the barrel end is the date May 16, 1931. This fantastic stadium relic resembles a fine piece of elegant furniture, with tremendous eye appeal that date to the days when Eddie graced the grounds of Mayo Island Park. (From the collection of George Stanford.)

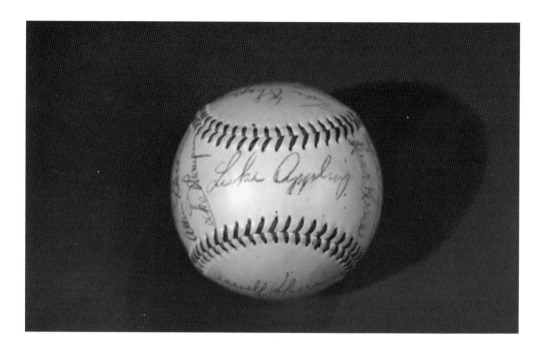

RICHMOND VIRGINIANS TEAM-SIGNED BALL, 1954. Scarce and historically significant is this official International League Spalding baseball from Richmond's initial year in the International League. This is most likely the rarest Virginians autographed ball to be found. Present are the signatures of 21 members of the original Vees, including Luke Appling, Ken Chapman, Bob Habenicht, Tommy Fine, Irv Medlinger, Jack Mayo, Wimpy Nardella, Bob Caffery, Darrell Johnson, Ken Wood, Allen Barbee, Russ Kerns, Jocko Thompson, Ken Heintzelman, Joe Tesauro, Marty Tabacheck, Ed Kasko, Frank Fanovich, Buzz Zieser, Dee Phillips, and Jim Dyck.

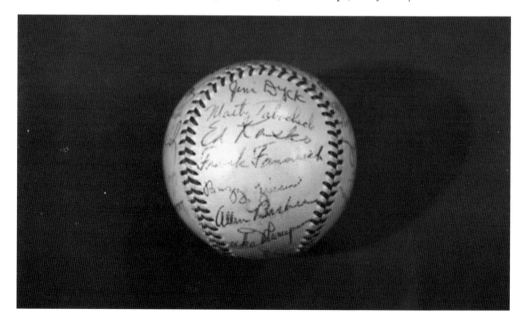

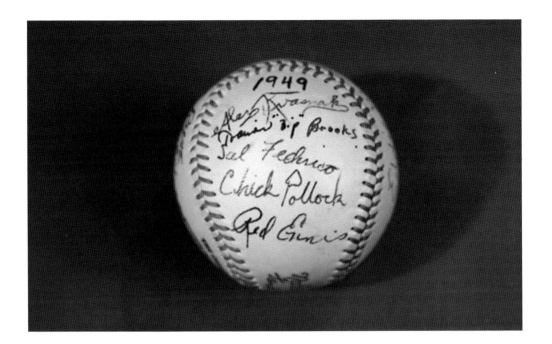

RICHMOND COLTS TEAM-SIGNED BALL, 1949. The Picasso of team-signed balls, this 1949 Richmond Colts baseball features the signatures of 20 team members. The phenomenal sphere boasts one of the finest stampings on a Spalding official National League ball. All the signatures on the creamy white ball are clearly legible and include Richard Klaus, Vinnie Smith, Larry Jensen, Ralph Davis, Alex Kvasnak, "Zip" Brooks, Sal Federico, Chick Pollock, Red Ennis, Eddie Mooers, Ray Carlson, George Sumey, Al Rossi, Jim Trexler, Joe Reeve, Joe Fortin, John Moore, Lew Saunders, and Carl Freed.

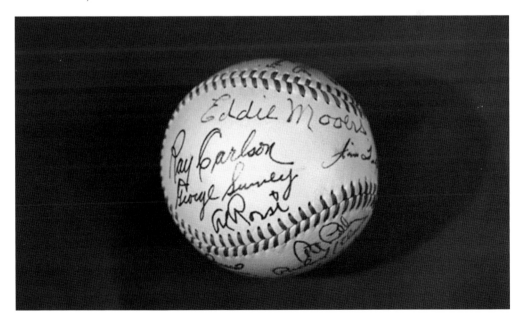

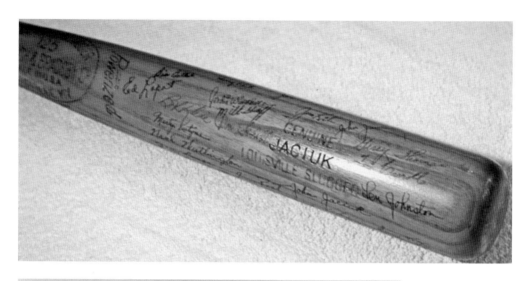

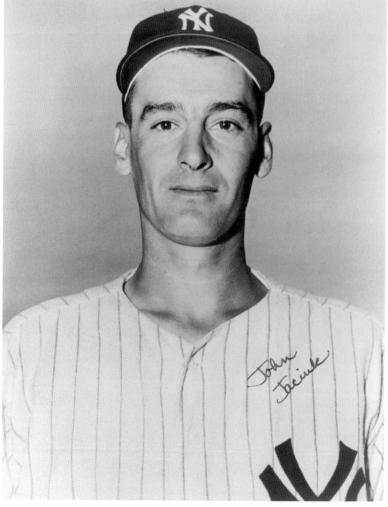

JOHN JACIUK GAME-USED BAT, 1957. "Yatch," the Vees hitsmith extraordinaire, pummeled International League pitchers for a .322 average in 1957. The willow of white ash pictured above is one the weapons John swung during that glorious season. The model K48 Louisville Slugger timber measures 35 inches and possesses the bold signatures of 20 of his teammates. Yatch reached the pinnacle of baseball batsmanship with this war club.

THIRD INNING: WAGON TONGUES AND HORSEHIDES

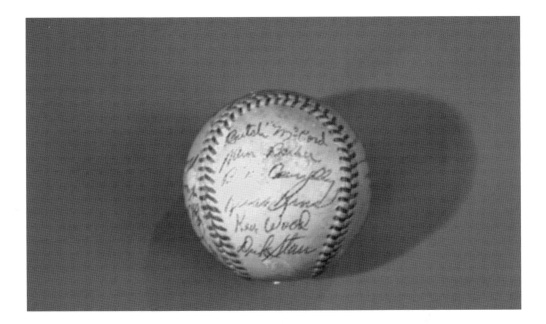

VIRGINIANS SIGNED BALL, 1955. This ball possesses the immaculate signatures of 21 players who comprised the Richmond club in 1955. The team was made up of ex-major-leaguers like Dick Starr, Bill Voiselle, Niles Jordan, Jim Konstanty, and manager Luke Appling. There are also future major-leaguers including Bob Richardson, Ed Kasko, and Russ Kerns. Rounding out the 21 signatures on this lightly toned official International League ball are Ken Wood, Bill Connelly, Allen Barbee, Wimpy Nardella, Neal Watlington, Joe Tesauro, Irv Medlinger, Ken Chapman, Bob Habenicht, Vic Marasco, Butch McCord, and Dee Phillips.

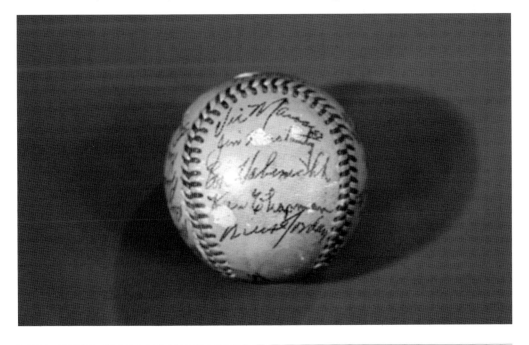

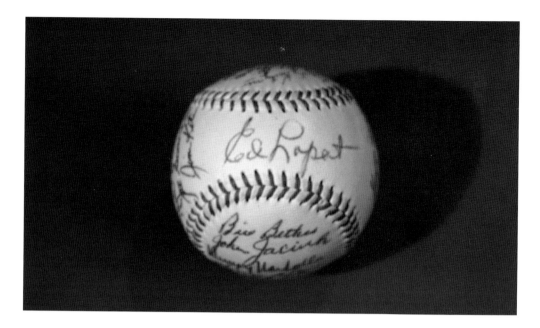

VIRGINIANS SIGNED BALL, 1957. This remarkable Vees team-signed ball has the handwritten signatures of 22 players. Richmond ended the season in third place, which gave them a berth in the league championship playoffs. The 22 blue-ink signatures on this pristine, creamy white ball include Ed Lopat, Jim Coates, Len Johnston, Tom Carroll, Milt Graff, Sonny Dixon, Gordie Winhorn, Neal Watlington, Joe Soares, Jim Kite, Bill Bethel, John Jaciuk, Wimpy Nardella, Harry Chiti, Bob Wiesler, Jim Post, Marty Kutyna, Bob Kline, Dan Schell, Jerry Lumpe, Gerry Thomas, and John James.

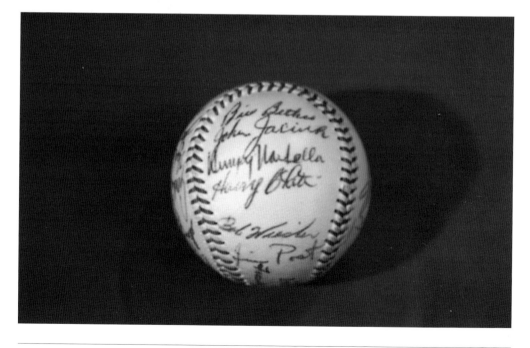

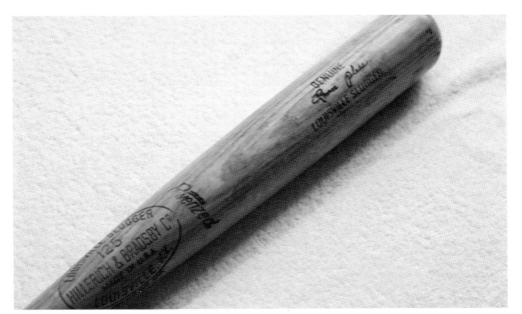

RANCE PLESS GAME-USED BAT. Wearing the wool for the Richmond Virginians in 1956 and 1958, Rance was known to wield a wicked bat. In 1955, he led the American Association in runs, hits, and batting average (.337). Displayed here is one of his game bats from the 1950s. This 34-inch, signature-model bat features a bold center brand Louisville Slugger 125 and signature stamping. The handle end is stamped K48, and the barrel shows evidence of this stick having come into contact with an untold number of fastballs. Pless also spent a portion of the 1956 season manning the hot corner for the Kansas City Athletics.

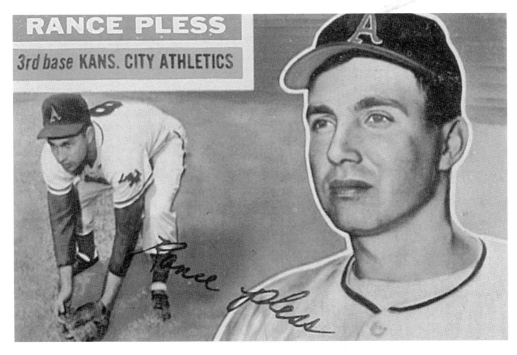

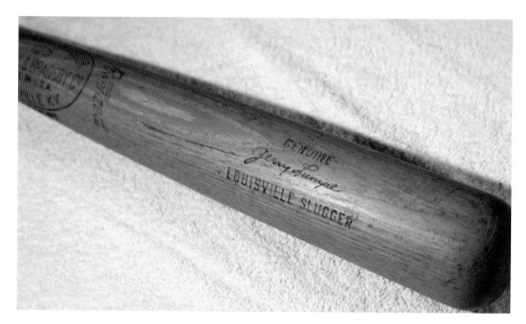

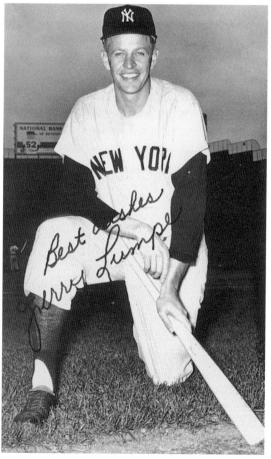

JERRY LUMPE GAME-USED BAT. Lumpe patrolled the infield garden for the Richmond Virginians in 1956 and part of 1957. This infielder stroked the ball for a respectable .279 average in 1956 and a menacing .298 in 1957 before being called up to Yankee Stadium. This 34-inch white-ash timber was retrieved from old Parker Field during the summer of 1956. This sensational lumber specimen certainly saw its share of action, displaying a handle crack and numerous bumps and bruises throughout the hitting surface as well as Jerry's signature stamped on the barrel end.

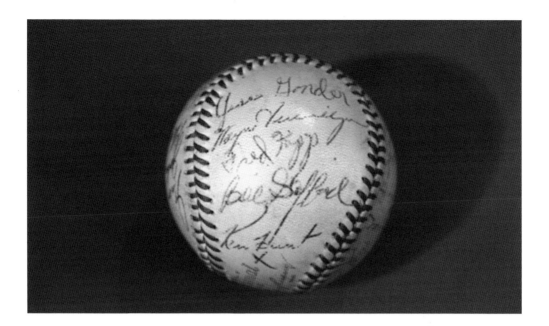

VIRGINIANS SIGNED BALL, 1960. The 1960 season will always remain special in the minds of Richmond Vees fans. Their second-place finish vaulted them into the International League playoffs. Presented here is an official International League ball that has been inked by team maestro Steve Souchock, player-coach and native Richmonder Gran Hamner, team batting leader Jesse Gonder, the "mighty mite" of the infield Fritz Brickell, and pitching leaders Bill Stafford and Gary Blaylock. Also present on the ball are Deron Johnson, Zack Monroe, Jim Bronstad, John Jaciuk, Gerry Thomas, Ray Bellino, Randy Gumpert, Ken Hunt, Jim Pisoni, Jack Reed, Ben Flowers, Art Ceccarelli, Bob Wiesler, Bill Short, Wayne Terwilliger, Fred Kipp, and Don Friederichs.

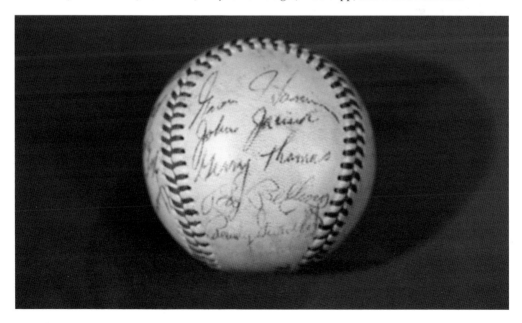

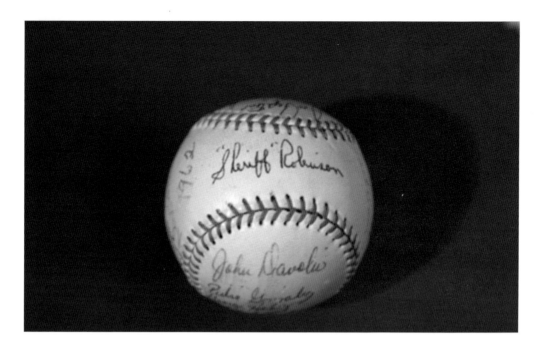

VIRGINIANS SIGNED BALL, 1962. With a new sheriff in town, manager Sheriff Robinson, the Vees of 1962 featured numerous future Yankees stars that inked this horsehide. This appealing blue-ink signed ball possesses the John Hancocks of slugger Joe Pepitone, Al Downing (who pitched the only no-hitter in Vees history), Jake Gibbs, Pedro Gonzalez, Gary Blaylock, Fred Kipp, Jim Bronstad, Mike Mathiesen, Jack Davis, Tom Umphlett, John Davolio, George Haney, Hal Stowe, Ben Mateosky, Al Hall, Paul Erickson, Bill Shantz, and "Sheriff" Robinson on the sweet spot.

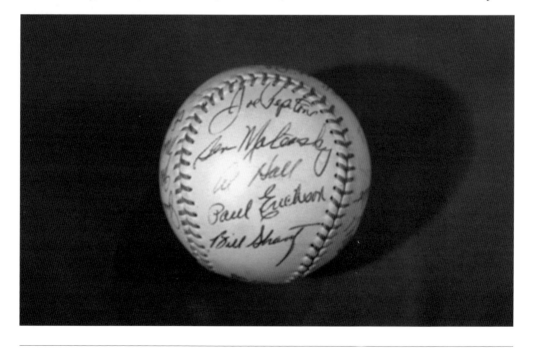

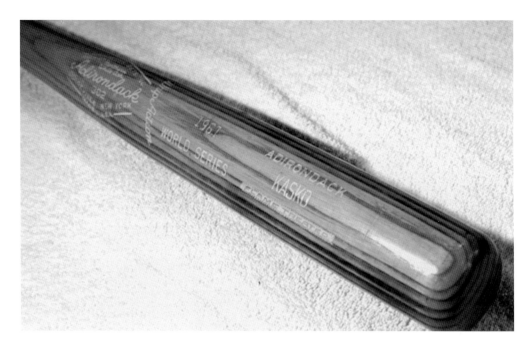

EDDIE KASKO 1961 ADIRONDACK WORLD SERIES GAME BAT. Eddie Kasko was a key member of the 1954 and 1955 Richmond Virginians. As a star shortstop for the Cincinnati Reds in 1961, he helped lead the team to the National League pennant and the World Series. In this series, which the Reds lost to the powerful Yankees, Eddie led the team in batting with a .318 average. This incredible piece of lumber was used by Eddie in the 1961 World Series. Manufactured by Adirondack, the 34-inch block-letter model of northern white ash was finished with a golden hue and stamped with bright-white letter graphics. It is a visually appealing example of a seldom-found World Series bat.

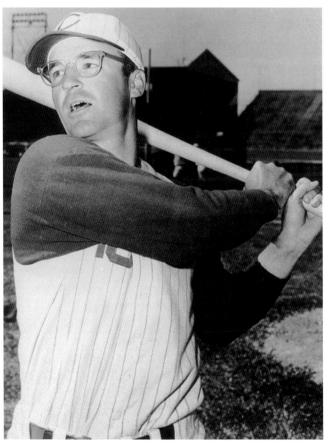

BASEBALL IN RICHMOND

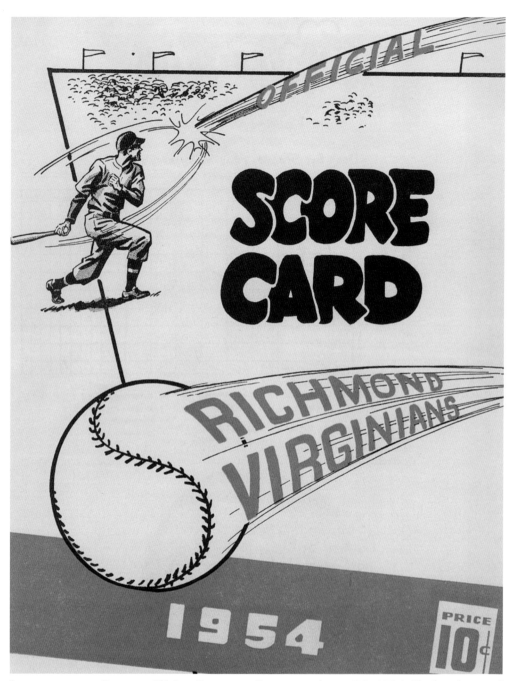

INTERNATIONAL LEAGUE: WE'RE OPEN FOR BUSINESS, APRIL 20, 1954. Twelve thousand diamond bugs showed up for the Richmond Virginians' cork-popper of the 1954 season. The Vees were hosting Harry Walker's Rochester Red Wings. This is a rare scored program for the first regular-season baseball game ever played at the renovated Parker Field. The primitive four-page Vees scorecard featured advertisements for Camel Cigarettes, McSweeny's Hams, and Tru-Aide. The price of the scorecard was a mere 10¢, with the lucky number on the back page.

Fourth Inning

Keeping the Score

The 1954 Richmond Vees

Many players have come and gone since our induction in 1954.
What a great influx of players, from that team in Baltimore:
Weatherly, Heintzelman, and Jocko, just to name a few—
We've got the Triple-A franchise, over 200,000 came to view.
The hiring of Luke Appling, our manager, was quite stellar,
And our pitching staff is led by a youngster named Nardella.
Ex-Brooklyn Dodger Marv Rackley led the team in hitting;
Our home-run leader, Jim Dyck, played outfield, which seemed quite fitting.
With Tommy Fines's 11 victories, did that moundsman look so great!
We had a future Boston manager, Darrell Johnson, behind the plate.
Let's not forget our locals, Bob and Monty, who hurled the ball that year,
And gave the Richmond fans more reason to come and cheer.
The bespectacled shortstop Kasko as a slick as a fox,
Not to be outdone by Johnson, he later managed the Red Sox.
Fridley, Kerns, and Wood, hot hitters we came to see.
Do not forget the 20-year-old rookie we called Allen Barbee.
With 37 different players, the Richmond uniforms they did grace,
The team won 60, lost 94, a lowly seventh place.

RICHMOND COLTS PROGRAM, 1936.
Due to flooding at Tate Field prior to the
season-opening game, the Colts played
some of their early games at City Stadium.
The program features a large picture
and write-up of the Colts' new manager,
George Ferrell. Programs sold for a mere
5¢, and fans could rent cushions for 10¢.

JUDGE LANDIS, IS THAT YOU? The cover
of this Richmond Colts home program
from 1945 features baseball commissioner
Kenesaw Landis. This 12-page program
features pictures of Colts owner Eddie
Mooers and Frank Rodgers, the Mustang
manager. Items of interest include the
Most Popular Player contest ballot, the
War Bonds giveaway ballot, the Lucky
Number drawing (in which a fan won
one grandstand ticket to see the Colts
play), and a personal voice recording.

HOME
ACME BICYCLES
Repairing
Phone 7-0566 : 418 W. Broad St.

COLTS
Official Scorecard

R. J. ROWLETT BICYCLE CO.

1944 - 10c

RICHMOND COLTS PROGRAM, 1944. This program for the Richmond Colts depicts Uncle Sam swinging a bat with a background including soldiers, military tanks and trucks, aircraft, and a baseball diamond. The program features eight pages richly adorned in local advertising, including Tantilla Gardens, "The South's Most Beautiful Ballroom," and Bill's Barbecue. This particular game pitted the Colts against the Newport News Dodgers, who had slugger Duke Snider playing right field.

RICHMOND COLTS PROGRAM, 1947. A fan of the Richmond Colts purchased this particular program in 1947. It includes a picture and biography of new Mustangs manager Bob Lotshaw, "who was injured in a crash with a Baltimore catcher early in the 1946 season." The program also includes pictures of Colts second baseman Pete Pavlik, the fastest Piedmont Leaguer in turning double plays.

MUSTANGS SCOREBOOK, 1948. This scorebook for the 1948 Richmond Colts season features pictures of team president Eddie Mooers, manager Charles "Greek" George, and star moundsman George Sumey. A hot dog or a pack of smokes cost 20¢, but peanuts and popcorn were just 10¢. Super advertisements included Rowlett Bicycles and McSweeny Sugar Cured Hams.

RICHMOND COLTS SCORECARD, 1953. Ten cents bought Colts fans this final-edition scorecard for their last appearance in the Piedmont League. This 12-page program-scorecard features pictures of the Richmond Colts team. Many local advertisements adorn the scorecard, including Garvin Hamner Service Station and Starlight Club Patio, "Richmond's Only Outdoor Ballroom." Ice cream and cigars were only 10¢ and cushions were rented, not sold.

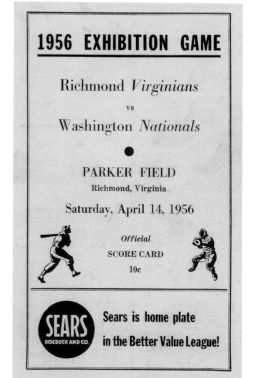

EXHIBITION GAME SCORECARD, 1956. This somewhat generic-looking scorecard was for an exhibition game played on April 14, 1956 between the Richmond Virginians and the Washington Nationals. The scorecard features rosters of each team, with the Vees having new manager Ed Lopat and Yankees "bonus baby" Frank Leja at first base. The Nationals were led by sluggers Pete Runnels, Roy Sievers, and Jim Lemon, with little-known rookie Harmon Killebrew waiting in the wings.

NATIONAL'S

NATIONAL'S		1	2	3	4	5	6	7	8	9	10	At Bat	R.	1st B	T.B.	P.O
Baker,	1 b.	3B-c	6-1	6-cf		SS-1B		1B								
Hoover,	c. f.	3B	*	6-3B	3B	6-cf								✓		
Powell,	r. f.	1B	*	3B	6-c									✓		
Burch,	l. f.	c-1B	*	4-1B	P-1B									✓		
White,	s. s.	c-1B	*	6-1B	x-2											✓
Knowles,	2 b.		*	*	SS-2B	6-1								✓		//
Gladmon,	3 b.	x	2B	3B-1B	6-c											✓
Cook,	c.	2B	1B	x	*											//
O'Day,	p.	x	x	x	2B-1											//
Runs		0	1	4	0	0	0	0	1							
Earned Runs																
1st base on errors												Game began				
Totals			5					6				1st to Bat,				

Aug. 24, 1885

Umpire,
Holland.

VIRGINIA'S

VIRGINIA'S		1	2	3	4	5	6	7	8	9	10	At Bat	R.	1st B	T.B.	P.O.	A.	E.
Greenwood,	s. s.	1B	*	6-3B	x-3												//	
Glenn,	l. f.	SS-1B	*	P-1B	P-1B													
Corcoran,	r. f.	6-r	*	6-4	1B							✓				✓		
Parker,	c f.	3B-1B	6-1B	2B-1B	x								✓			✓		
Householder,	c.	P-1B	3B	6-3B	SS-1B											///		
Tomney,	3 b.	x	2B	2B	*													
Latham,	1 b.		1B	6-c	6-1B											//		
Higgins,	2 b.		2B-1B	c-2B	3B							✓				✓		
Pyle,	p.		*	2B-1B	x											////		
Runs		0	0	4	0	0	0	0	0	1								
Earned Runs																		
1st base on errors											Game began							
Totals								5				1st to Bat,						

RARE SCORECARD, 1885. Displayed here is an extremely rare scorecard of the Richmond Virginias Baseball Club for a game played against the Washington Nationals in August 1885. Conspicuously missing from the Richmond line up are Billy Nash, Pop Tate, and Dick Johnston, who had been sold to the Boston Beaneaters earlier in the month. Native Richmonder Ed Glenn, who later played in the bigs with Pittsburgh and Kansas City, led the Virginias.

Officers Virginia League

JAKE WELLS, - - President

W. B. BRADLEY, - Vice-President

E. N. GREGORY, Jr. Sec'y-Treas.

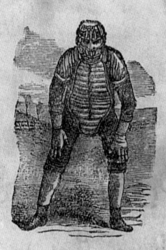

Managers of Teams

PERRY H. LIPE, - - - Richmond

BOB PENDER, - - - - Norfolk

J. J. GRIM, - - - - - Lynchburg

STEVE GRIFFIN, - - - Portsmouth

CHAS. A. SHAFFER, - - Roanoke

R. M. STAFFORD, - - - Danville

1

SCORECARD SCHEDULE, 1908. This extremely rare scorecard for the Richmond Lawmakers of 1908 features Virginia League team rosters, the schedule for 1908, team managers, and league officers—44 pages chocked full of information on the Virginia League. The scorecard section shows Richmond entertaining Danville, with the team lineups written in pencil. The Richmond lineup featured Kinzler and Riggs batting in the third and fourth slot, with manager Lipe playing the hot corner and batting second. McKenzie toed the rubber for Richmond. Some of the advertising included A. Meyers's Son's High-Grade Wagons and Ben L. Metzger Straight Whiskeys.

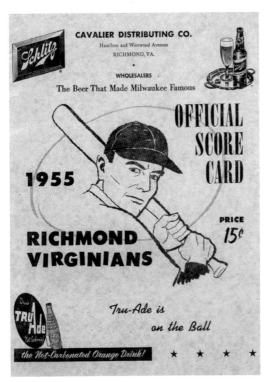

SCORECARD, 1955. The price of the official Vees scorecard for the 1955 season was raised to 15¢. The scorecard colors remained orange and black, but the total pages were expanded to 24. Of special interest are the 1955 Richmond player roster, the International League schedule, the photograph of Richmond manager Luke Appling, and the "Flag Story" featuring International League pennant winners dating back to 1884.

RICHMOND SCOREBOOK, 1956. The price of a program was reduced to 10¢ and a new cover was unveiled. Features included a picture and article on the Virginians' new manager, Eddie Lopat, the former New York Yankee hurler. Again advertisements were abundant, with a favorite being the picture of the "Kingan Queen," Richmond's own Sunshine Sue, promoting Kingan's All-Meat Frankfurters. For the first time, a ballot for "Popular Player" is included. Snow cones were 15¢, Cracker Jacks 10¢, and pencils 5¢.

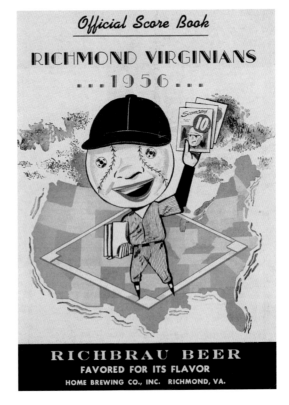

INTERNATIONAL LEAGUE PLAYOFF SCORECARD, 1957. The first post-season classic for the Richmond Virginians was set in old Parker Field. On September 13, 1957, the Richmond Vees prepared to battle the invaders from the north, the Buffalo Bisons, for advancement to the championship series of the International League. Displayed here is a scorecard from this historic event. This fold-open International League playoff program cost only 10¢.

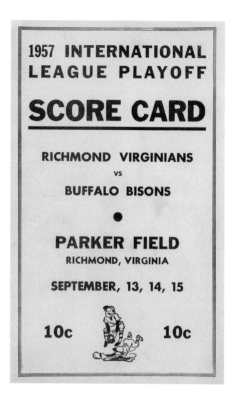

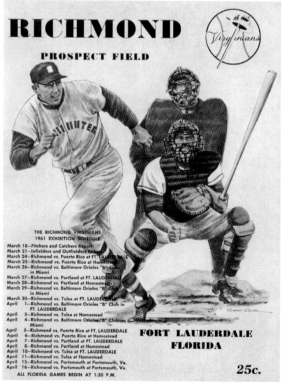

RICHMOND SPRING TRAINING PROGRAM, 1961. The Broward Motor Hotel was the Richmond baseball club's home away from home, and it featured the Patio New Orleans, where one could dine by candlelight. The cover features the 1961 Richmond exhibition schedule, with their home games played at Prospect Field in Fort Lauderdale. The interior features their spring roster and a super article on the Yankees' prize catch, new Richmond manager Cal Ermer.

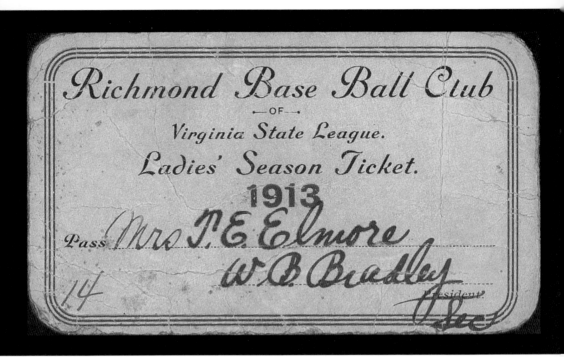

LADIES' SEASON TICKET, 1913. Unique for the period, this historical Ladies' Season Pass for the 1913 season was issued to Mrs. T. E. Elmore by the Richmond Baseball Club of the Virginia State League. The Richmond Club for the 1913 season finished in third place with a 74-60 record.

FIFTH INNING

THE PASTEBOARDS

PUNCH MY TICKET

50¢ for a ticket, bleachers of old Parker Field,
While catching foul balls there, it seemed quite a deal.
Lennie Johnston at bat, I'd never look away,
Knew it wouldn't be long before he'd hit one my way.
Seldom a night did we leave without a ball;
That's why this bleacher ticket seemed quite the windfall.
Now with this lad's experience, many years before,
Let's gaze upon some tickets from days of yore.
We start in 1912, with Master Taylor Scott,
Then 1913, this Ladies' Season Ticket was quite hot.
With the Colts playing well, fans never left sadly,
While both of these passes were penned by President Bradley.
1938 to Mayo Island, where many are seen fishin',
But we have a 40¢ ticket for one general admission.
1942 the new park called Mooers Field we land,
40¢ here, ladies or boys, find seats in the grandstand.
1954 Giants versus All-Stars, a rare Negro League game,
Fifty-five cents to get in, all tickets the same.
First game at Parker Field, quite a historic day,
April 8, 1954, the New York Yankees came to play.
April 12 and 13, 1958, Ted Williams came to call,
On consecutive days hit home runs, over the right-field wall.
These tickets carry memories, we collect them by the hoards,
But the turnstillers of yesteryear, just considered them pasteboards.

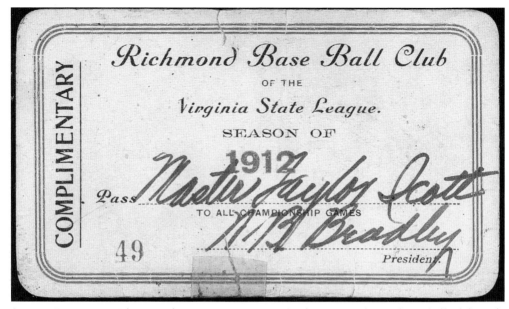

SEASON PASS, 1912. This complimentary season pass for the 1912 Richmond Baseball Club made out to Master Taylor Scott has a beautifully penned signature of team president W. B. Bradley. One can only envision Master Taylor proudly displaying this pasteboard as he passed through the turnstile of old Broad Street Park.

BASEBALL—Value 40c

This ticket entitles bearer to one general admission or can be applied at full face value on purchase of any other seat, for any one home game played by the

RICHMOND COLTS

—at—

MAYO ISLAND — 14TH STREET

THIS TICKET GOOD FROM APRIL 22 TO SEPTEMBER 7, 1938

Detach in Presence of Attendant

1938 MAYO ISLAND BASEBALL TICKET. This ticket had a 40¢ value and entitled the bearer to one general admission. Mayo Island, or Island Park as it was sometimes called, had at this time been renamed Tate Field in honor of Richmond baseball legend Ed "Pop" Tate.

"Ladies or Boys" Mooers Field Ticket Stub, 1942. This ticket stub is for "ladies or boys" admission to the grandstand at the new ballyard named Mooers Field. The ticket, which is actually bright orange, is dated 1942 and states a rain check policy. The admission price found on the reverse was 40¢.

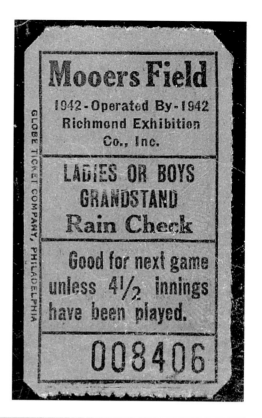

International League Pass, 1958. This seldom-seen International League pass for the 1958 season pass "extends the courtesy" of parks in Buffalo, Columbus, Cuba, Miami, Montreal, Richmond, Rochester, and Toronto. The pass has the stamped signature of league president Frank Shaughnessy.

This Ticket and (55¢)

ADMIT ONE

PARKER FIELD

Negro Eastern League Game

Richmond VS **HOPEWELL**

GIANTS ALL=STARS

SUN. JUNE 27, 1954 3:30 P. M.

NEGRO EASTERN LEAGUE TICKET, 1954. In the wake of integration, the failing Negro League clubs began to disband, with their talent trickling down to smaller minor league black circuits. One circuit, the Negro Eastern League, had a team in Richmond, Virginia. This extremely rare ticket is for a game played on Sunday, June 27, 1954, at the fabled Parker Field. This historic baseball game matched the Richmond Giants against the Hopewell All-Stars.

HISTORIC APRIL 8, 1954, BASEBALL TICKET.
This rare ticket stub for inaugural baseball game at Parker Field was for an exhibition game pitting the world champion New York Yankees against the Richmond Virginians. This historic game was played on April 8, 1954, and had many sidelights, including a 41-minute rain delay.

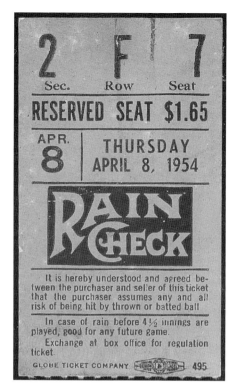

"OPENING NITE" TICKET, 1955. This rare pasteboard is for the April 19 opening-night game at Parker Field for the 1955 season. Taking a cue from the Brooklyn Dodgers, who often had unique tickets for their opening day contest, this ticket stub is shaped like a baseball and featured the Richmond Virginians against the Montreal Royals.

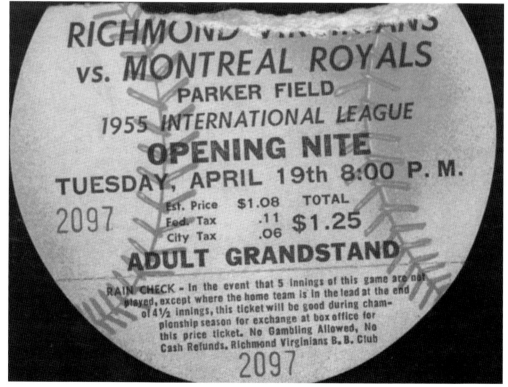

7 J 12
Sec. Row Seat

RESERVED SEAT $1.65

1

The management reserves the right to revoke the license granted by this ticket by refunding purchase price.

⸱RAIN CHECK⸱

It is hereby understood and agreed between the purchaser and seller of this ticket that the purchaser assumes any and all risk of being hit by thrown or batted ball.

In the event that 4½ innings of this game are not completed, this rain check will be exchanged for this price ticket to any future regularly scheduled championship game.

NO GAMBLING ALLOWED
NO CASH REFUNDS

GLOBE TICKET CO., PHILA.

RICHMOND VEES FIRST PLAYOFF TICKET, 1957. This ticket stub is for the first home playoff game ever experienced by the Richmond Virginians. The tilt was played at Parker Field on September 13, 1957, and pitted the third-place Vees against the second-place Buffalo Bisons. The Vees won the contest 6-3.

9 D 9
Sec. Row Seat

RESERVED SEAT $1.65

SUN., APRIL 13, 1958

The management reserves the right to revoke the license granted by this ticket by refunding purchase price.

⸱RAIN CHECK⸱

It is hereby understood and agreed between the purchaser and seller of this ticket that the purchaser assumes any and all risk of being hit by thrown or batted ball.

In the event that 4½ innings of this game are not completed, this rain check will be exchanged for this price ticket to any future regularly scheduled championship game.

NO GAMBLING ALLOWED
NO CASH REFUNDS

RICHMOND BASEBALL, INC.
GLOBE TICKET CO., PHILA.

APRIL 13, 1958: WILLIAMS WALLOPS ANOTHER. A significant ticket stub in Richmond baseball history is this pasteboard from a game played between the Richmond Vees and the Boston Red Sox. In dramatic fashion, Ted Williams pinch-hit and proceeded to deposit the pill over the Parker Field right-field fence for a round-tripper. This feat matched the pinch-hit homer he produced the previous day.

FULL RICHMOND TICKET, 1960. For ticket collectors, the hardest to acquire is the full, unused baseball ticket. Displayed here is one such full ticket for a game that saw the Richmond Vees take on the Toronto Maple Leafs. This unused reserved-seat ticket cost $1.65, and the tilt was played on Tuesday, August 16, 1960.

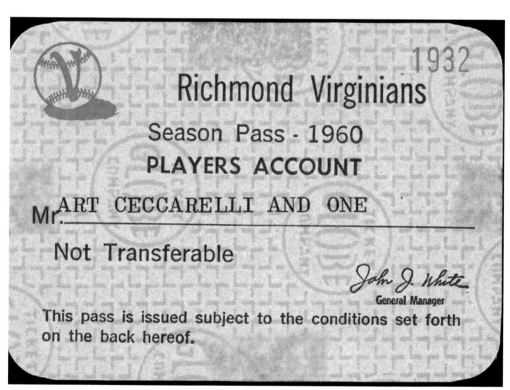

PLAYER PASS, 1960. Pictured here is a season pass on a player's account for the Richmond Virginians' 1960 season. The pass is for Art Ceccarelli and one guest it features a Vees logo at the top and a facsimile signature of team general manager John J. White at the bottom. "Chic," as he was nicknamed, was a southpaw pitcher for the Vees for three seasons.

VIRGINIANS GAME-WORN ROAD JERSEY, 1954. Welcomed to the International League scene in 1954, the Richmond Virginians proudly took up the orange and black of the team they replaced, the Baltimore Orioles. Viewed here is an astounding first-year uniform of the Richmond Vees. Rawlings manufactured this size-40 jersey with black piping down the front, shoulders, and sleeve ends. The jersey front features the two-color, heavy felt, orange-on-black lettering "Richmond" arched across the chest.

SIXTH INNING

WEARING THE RICHMOND WOOLS

SPANGLES

Some will call them unies, spangles, and much more,
Oh so many colors, our Richmond players wore.
There were Bloody shirts of red, the Crows dressed in black,
Brightly colored Bluebirds, Johnnie Rebs, gray was back.
Don't forget the home whites our Richmond Colts would wear,
The Richmond Vees in pinstripes, the fans they did stare.
Oh, the styles so varied, looking back at yesteryear,
Wearing the bib fronts and lace-ups, no team did our guys fear.
Bloomers—some called them knickers—were the pant of the day,
Often they were quilted, with padding they did stay.
Then there was the pillbox, well positioned on the head,
Many preferred the short-bill, for this notion has been spread.
And one so rare with sleeves, they would detach,
Quite unique a concept, this style it did not catch.
Whether flannel blends or double knits, the stands were always full,
To cheer their favorite players, who wore the Richmond Wools.

DICK STARR WARM-UP JACKET, 1954. Vees pitcher Dick Starr wore this nylon "black beauty" warm-up jacket during the inaugural season of 1954. Starr, who twirled the first regular-season game and also stroked a home run for Richmond, was a former major-league pitcher. This lined jacket features three orange stripes at the collar, waistband, and sleeve ends. The team name "Virginians" is prominently embroidered on the upper left sleeve. A "MacGregor" label with size-46 tag is displayed alongside a "Harris-Brenaman Richmond, Virginia" cloth label.

RICHMOND VIRGINIANS PLAYER CARRY BAG. This relic salvaged from the locker room of old Parker Field is a player carry bag. Used on road trips to the likes of Havana, Cuba, and Toronto, Canada, these canvas, zippered travel bags possessed the tools of the trade, the players' most prized possessions. Whether he stored gloves, balls, cleats, or uniforms, each player had his own Richmond Virginians numbered travel bag. This bag measures 24 inches by 12 inches and has the number 9 stenciled on each end.

RICHMOND VIRGINIANS GAME-WORN JERSEY, 1958. A phenomenal Richmond Virginians Spalding road uniform from 1958, this gray flannel, button-down garment boasts "Richmond" arched across the chest and the number 49 applied to the back in like fashion. On the left front tail of jersey is the Spalding manufacturer's label, accompanied by a tag denoting size 44.

RICHMOND VIRGINIANS–NEW YORK YANKEES PLAYER'S JACKET, 1950S. This stunning navy-blue warm-up jacket's wool outer shell has side welt pockets trimmed in matching leather, with the neck, waist, and cuffs in two-color knitted material. The name "Sturdivant" is embroidered in the waistband of this size-46 jacket. Tom Sturdivant never wore the wools of Richmond, so this jacket was apparently sent down to the Yankees minor-league farm club, which was customary for this era. The sewn-on team name "Virginians" in heavy felt blazes across the chest, replacing but not forgetting the fabled "Yankees" that had adorned this piece in earlier years.

BILL STAFFORD'S GAME-WORN RICHMOND VEES HAT, 1950S. Bill Stafford first ascended to the mound at old Parker Field in 1957 at the age of 18. This hat was obtained directly from the Stafford family and displays the "Wilson Professional Cap" tagging in the sweatband. The hat features a navy-blue crown and brim and boasts the Vees' familiar running R logo, which is embroidered on blue felt and applied to the hat. Bill Stafford's name is printed neatly in the brim.

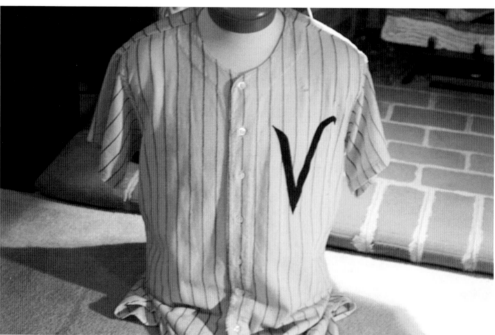

NEW OWNER, NEW UNIFORMS, NEW "V," 1963. New ownership for the 1963 season brought about the alteration of the old Vees logo on the chest of the team jerseys. New Wilson uniforms, the home pinstripes, now featured a different V lettering style on the left chest. This new V featured a small loop on one side, unlike the fancier V of seasons past. The size-42 jersey features the famous heavy-cloth "9" on the back and a Wilson label on the collar. Could this have been an old New Yankee Roger Maris jersey that was sent down to the minor-league affiliate, as was customary for this era? Probably not, but it does enter one's mind.

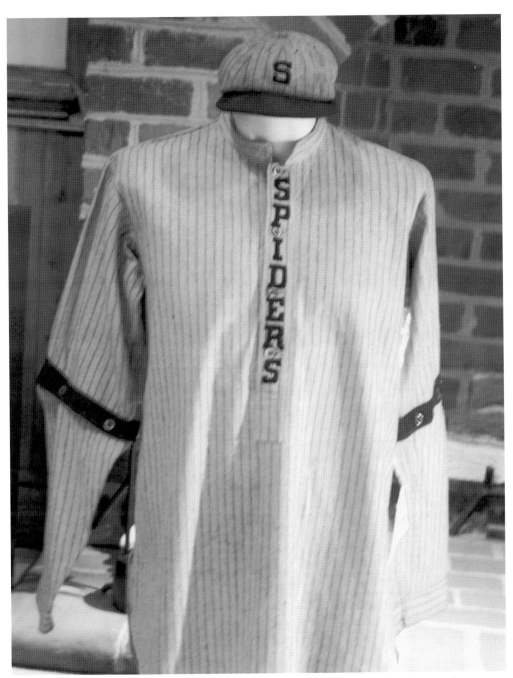

RARE SPIDER DETACHABLE-SLEEVE UNIFORM. This 1890–1910 detachable-sleeve uniform is one of the rarest styles for baseball uniform collectors. This phenomenal pinstripe uniform was made by A. G. Spalding Company and features the name "Spiders" in block letters down the front of the jersey. Could this historic piece be from the University of Richmond nine, who fielded a most proficient team at the time, or could this be from the legendary Cleveland Spiders of the National League?

Broad Street
BASE-BALL PARK

Base-Ball Exhibition
Dates of the Richmond Club

March 25, Philadelphia Nationals
" 26, Richmond College
" 28-29, Washington
April 1-2, Newark
" 4-5, Brooklyn
" 6, New York Nationals
" 8-9, " " Americans
" 11-12, Rochester
" 15-16, Altoona
" 19, Montreal

Games Called 4 P. M.
Admission, 25c Grandstand, 15c

BASEBALL EXHIBITION SCHEDULE, 1910. This nearly 100-year-old schedule gives the pre-season exhibition schedule for the Richmond Colts. The quite challenging schedule included the major-league nines of Philadelphia, Washington, Brooklyn, and New York. The games were called at 4:00 pm at the historic Broad Street Baseball Park. The afternoon entertainment would only cost the cranks 25¢ admission, or 15¢ if one preferred the view from the grandstand.

SEVENTH INNING

ARTIFACTS AND MEMORABILIA

GRANDPA'S ATTIC

Ever find a baseball memory tucked away in a drawer?
Scorecard, ticket, autograph, I bet you searched for more.
A trip to Grandpa's attic, among the trunks and wood,
Hoping to find that trinket, from his baseball's boyhood.
This area dimly lit, only the hunt on my mind,
Please help me, Lord, with a precious baseball find.
With Mom out shopping, must make this journey quick,
Remembering Grandpa's stories about Babe Ruth and The Mick,
Making it to where the trunks are kept, but only by feel,
What if any baseball artifacts, would this huge box conceal?
With exciting anticipation, I threw open the large top,
Flashlight in hand, but all I found was Grandma's kitchen mop.
Time running out, one trunk to go, Mom would soon return.
If she finds me snooping way up here, my butt she would burn.
The second trunk much dirtier, oh how I hoped it belonged to him.
Could this be the place he hid his baseball gems?
Tugging on the lid, finally tossing fully back,
Peering with my flashlight, shoeboxes in a stack,
Grabbing from the boxes the cards I did explore,
With names like Gehrig and Mantle and even Bobby Doerr.
Then with one last glance, I thought I saw a hat,
Upon further investigation, pulled out a wooden bat,
Covered with dirt and years of dust, the name could not see,
Rag in hand, rubbing hard the letters seen by me.
Oh, thanks up there to Grandpa, for telling me the truth,
This bat I had in my hand was signed "The Bambino" Babe Ruth.

PARKER FIELD GRANDSTAND SEATS. Rescued from the wrecking ball, this trio was originally part of the hallowed Parker Field grandstand. These wooden seats with metal framework encase three adjoining chairs, with each comprised of two wooden backrest slats and a wooden folding seat. With a vintage coat of orange paint, the seats are respectively identified with seat numbers one, two, and three in black numerals. If furniture could talk, these would recall jeers and excitement from the warm summer evenings at old Parker Field.

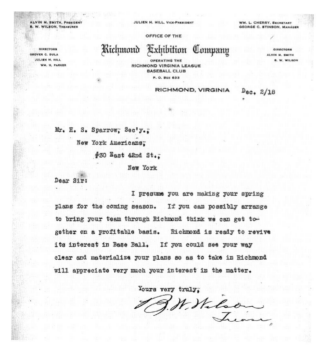

RICHMOND BASEBALL CLUB LETTER, 1918. This typed letter is to H. S. Sparrow of the New York Americans baseball club from B. W. Wilson of the Richmond baseball club. The letter is dated December 2, 1918, and asks if the New York club, in making their spring plans, could possibly arrange to bring the Yankees through Richmond. Treasurer Wilson states, "We can get together on a profitable basis." Any documents relating to early Richmond baseball are extremely rare.

RICHMOND VIRGINIANS BALLPOINT PEN. This is the only Richmond Virginians ballpoint pen the author has ever seen. He received the pen from Roy Dietzel, an infielder for the 1955 Richmond Virginians. This orange and gold ballpoint features crossed bats and baseball logo with "Richmond Virginians Baseball Club" imprinted in black.

1954 International LEAGUE SCHEDULE 1954

FRANK J. SHAUGHNESSY, *President*

TEAMS— MANAGERS	AT MONTREAL (Home Games)	AT OTTAWA (Home Games)	AT TORONTO (Home Games)	AT BUFFALO (Home Games)
MONTREAL (Royals) Max Macon Games Away→	MONTREAL STADIUM Cap: 20,142 Radio: CFCF TV: CBFT	May 11, 12, 13 June 14, 15-15, 16 July 2, 3, 14, 15	May 8, 9-9* July 30, 31 Aug. 1-1*, 2-2†, 17, 18	April 25-25*, 26, 27 July 5-5†, 6, 7 Aug. 30, 31 Sept. 1
OTTAWA (Athletics) Less Bell Games Away→	May 2-2* June 11, 12, 13* July 4-4*, 12, 13 Sept. 6-6†	LANSDOWNE STADIUM Cap: 12,000 Radio: CFRA TV: NONE	May 16-16*, 17 June 20-20* July 16, 17, 18-18* Aug. 8-8*	April 21, 23 July 8, 9, 10, 11*, 25* Aug. 13, 14, 15* Sept. 5*
TORONTO (Maple Leafs) Luke Sewell Games Away→	May 28, 29, 30-30* June 25, 26, 27-27* Aug. 3, 4, 5	May 6, 7, 14, 15 June 17, 18, 19 Aug. 6, 7, 31 Sept. 1	MAPLE LEAF STADIUM Cap: 18,500 Radio: CKEY TV: CBLT	May 31-31† June 1, 2, 21, 22, 23, 24 Aug. 27, 28, 29*
BUFFALO (Bisons) Wm. C. Hitchcock Games Away→	May 18, 19, 20 June 28, 29, 30 July 1-1† Sept. 10, 11, 12*	April 24, 29, 30 May 1 July 27, 28-28, 29 Sept. 2, 3, 4	May 24-24†, 25, 26 June 11, 12, 13-13* July 19, 20, 21	OFFERMAN STADIUM Cap: 15,012 Radio: WKBW TV: WBEN
ROCHESTER (Red Wings) Harry Walker Games Away→	May 5, 6, 7 June 17, 18, 19, 20-20* Aug. 6, 7, 8*	May 21-21, 22 June 24-25, 26 Aug. 2-2†, 3, 4, 5	May 18, 19 July 2, 3, 4-4* Aug. 21, 22-22* Sept. 6-6†	May 27, 28, 29, 30-30* June 15, 16 Aug. 9, 10, 11, 12
SYRACUSE (Chiefs) "Skeeter" Newsome Games Away→	April 29, 30 May 1 June 21, 22, 23, 24 Sept. 2, 3, 4, 5*	May 27, 28, 29 June 28, 29, 30 July 1-1† Sept. 9, 10-10	June 4, 5, 6-6*, 14, 15, 16 Aug. 23, 24, 25, 26	May 2-2*, 3, 4 July 12, 14, 15 Sept. 6-6†, 7, 8
RICHMOND (Confederates) Luke Appling Games Away→	May 21, 22, 23-23* July 19, 20, 21 Aug. 13, 14, 15-15*	May 24-24†, 25, 26 July 22, 23, 24-24 Aug. 10, 11, 12	May 2-2*, 4 July 1-1† Sept. 10, 11, 12-12*	May 5, 6, 7 June 17, 18, 19, 20-20* July 16, 17, 18*
HAVANA (Cubans) Regie Otero Games Away→	May 24-24†, 25, 26, 27 July 22, 24, 25 Aug. 10, 11, 12	May 18, 19, 20 June 21, 22 23-23, 24 July 19, 20, 21	April 29, 30 May 1 July 26, 27, 28, 29 Aug. 13, 14, 15-15*	May 21, 22, 23-23* June 25, 26, 27* Aug. 16, 17, 18, 19

*Sundays †Holidays §Not Scheduled at Date of Publication

1953 League's Batting Champ — SANDY AMOROS (Montreal) .354

Double Date Indicates Doubleheader

1953 League Attendance — 1,714,211

(28)

Class AAA	International League Club Pr...	
	Montreal—Hector Racine Ottawa—Connie Mack Toronto—Jack Kent Cooke Buffalo—W. O. Briggs, Jr.	Rochester—Elmer Syracuse—Martin Richmond—Harry Havana—Roberto

	AT ROCHESTER (Home Games)	AT SYRACUSE (Home Games)	AT RICHMOND (Home Games)	AT HAVANA (Home Games)
	May 14, 15, 16* 31-31† July 16, 17, 18* Sept. 7, 8, 9	April 23, 24 July 8, 9, 10, 11-11*, 26, 27, 28	June 1, 2, 3, 4-4, 5 Aug. 25, 26, 27, 28, 29*	June 6*, 7-7, 8, 9, 10 Aug. 20, 21, 22*, 23, 24
	May 8, 9*, 23* June 27* July 5-5†, 30, 31 Aug. 1*, 17, 18	April 25-25*, 26, 27 May 30-30* 31-31† July 6, 7 Sept. 12*	June 6-6*, 7, 8, 9, 10 Aug. 20, 21, 22*, 23, 24	June 1, 2, 3, 4-4, 5 Aug. 25, 26, 27, 28, 29*
	May 11, 12, 13 June 8-8, 9, 10 Sept. 2, 3, 4, 5	May 21, 22, 23* July 5-5†, 23, 24, 25* Aug. 10, 11, 12	April 24, 25-25* 26, 27 July 6, 7, 8, 9-9, 10	April 20, 21, 22-22, 23 July 11*, 12 13, 14, 15
	June 4, 5, 6-6* July 22, 23, 24 Aug. 23, 24, 25, 26	June 7, 8, 9, 10 July 2, 3, 4-4* Aug. 20, 21, 22*	May 13, 14, 15, 16-16*, 17 Aug. 1*, 2, 3	May 8, 9-9*, 10, 11, 12 Aug. 4, 5, 6, 7, 8*
	RED WING STADIUM Cap: 15,000 Radio: WBBF TV: §	June 1, 2, 3 July 19, 20, 21 Aug. 27, 28, 29-29*, 30	April 20, 21, 22-22, 23 July 11-11*, 12, 13, 14, 15	April 24, 25-25* 26, 27 July 6, 7, 8, 9-9, 10
	May 24, 25, 26 June 11, 12, 13-13* Aug. 13, 14, 15-15*	MACARTHUR STADIUM Cap: 10,000 Radio: WNDR TV: §	May 8, 9-9*, 10, 11, 12 Aug. 4, 5, 6, 7, 8*	May 13, 14, 15, 16-16*, 17 July 30, 31 Aug. 1*, 2, 3
	April 29 May 1 June 21, 22-22, 23, 24 July 25*, 26, 27, 28	May 18, 19, 20 June 25, 26, 27-27* Aug. 16, 17, 18, 19	PARKER FIELD Cap: 10,000 Radio: WLEE TV: NONE	June 11, 12, 13*, 14, 15 Aug. 30, 31 Sept. 1, 2, 3, 4
	May 2*, 3, 4 June 28, 29-29, 30 July 1 Sept. 10, 11, 12*	May 5, 6, 7 June 17, 18, 19, 20-20* July 16, 17, 18*	May 29, 30*, 31-31† July 3, 4*, 5-5† Sept. 5*, 6†, 7	GRAN STADIUM Cap: 28,000 Radio: § TV: CMQ

DO YOU KNOW — Sherman Lollar, Chicago White Sox catcher... fielding average of all backstops in the American League ... mark of .994.

(29)

CONFEDERATES: A SHORT-LIVED NICKNAME. As seen on the 1954 International League schedule, the Richmond club is nicknamed the Confederates. This team name, however, was very short-lived, as it drew the ire of many in the community and was quickly eliminated. The more appealing Virginians was soon adopted as the nickname and remained for the next 11 seasons.

RICHMOND COLTS LEDGER BOOK. This extremely spectacular relic from Eddie Mooers's 1940s–1950s Richmond Colts baseball club includes salary advances to players, sale of players, a working agreement with the New York Giants, purchase of players, and many other interesting categories. Of interest is the entry on August 11, 1944, for the sale of player-manager Ben Chapman to the Brooklyn Dodgers for the sum of $20,000 and an entry on May 6, 1949, for cost of "seats for colored grandstand" at $1,330.17.

SWEENEY TRANSFER TO RICHMOND, 1915. The one-page official uniform agreement is for the transfer of a player by a major-league club. The player is Edward Sweeney, an eight-year Yankee veteran catcher. Sweeney was transferred to the Richmond Exhibition Company "for and in consideration of the sum of Three Hundred ($300) dollars." New York president Jacob Ruppert and Richmond president Alvin M. Smith, signed this officially executed document.

"Daddy" Boschen's Shoe Shop Advertisement.
Henry C. Boschen was a shoe manufacturer and
the dean of professional baseball in Richmond.
Working in his shoe shop were the likes of Billy
Nash, "Pop" Tate, and Charlie Ferguson, whose
talents formed the nucleus for Daddy Boschen's
Shoe Shop Team in the late 1870s and 1880s.

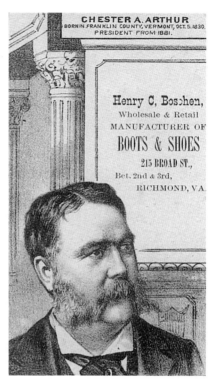

Player Transfer Document, 1917. This rare
document is for the transfer
of player Everett Bankston
from the New York American
League club to the Richmond
Exhibition Company. The
document calls for Bankston
to be paid $1,500 for the
1917 season, with signatures
of Yankee president Jacob
Ruppert and Richmond
president Alvin Smith.

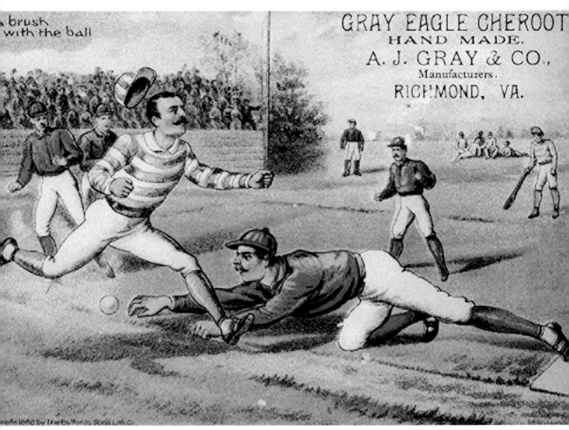

RICHMOND VIRGINIA BASEBALL TRADE CARD. In the late 19th century, merchants often produced colorfully illustrated cards to distribute as product advertisements. This baseball theme trade card, "A Brush with the Ball," was produced for A. J. Gray and Company of Richmond, Virginia, to promote handmade Gray Eagle Cheroots.

Matchbook Schedule, 1948. This seldom-seen matchbook includes the 1948 Richmond Colts' baseball schedule at Mooers Field. The exterior states the night games begin at 8:00 p.m., with Sunday games at 3:00 p.m. It includes a caricature of a pitcher in his wind-up. Could this pitcher be Carl Freed, the rookie from Gordonsville?

Dr. Parker's Indoor Baseball Board Game, 1932. Invented by the granddaddy of Richmond baseball, Dr. William H. Parker, this realistic and challenging baseball board game was produced in 1932 by the Home Baseball Company of Richmond, Virginia. Present are original home baseball scorecards, a player disc, playing cards, and home baseball testimonial from baseball great John McGraw. This is certainly one of the most unique Richmond baseball collectibles of its type, and to be invented by Dr. Parker simply adds to the mystic of Richmond's baseball past.

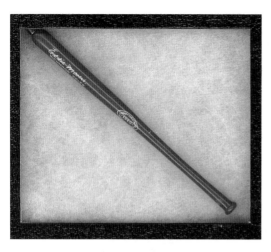

RICHMOND COLTS CHRISTMAS MECHANICAL PENCIL. Eddie Mooers was still basking in the glow of the Colts' first-ever Piedmont League championship in 1940 when he placed his order for these fantastic bat pencils. This high-quality celluloid mechanical pencil features the center brand, which states "Merry Christmas 1940 Happy New Year," and on the barrel end is the favorite autograph of Eddie Mooers's Richmond Colts. These pencils were certainly made for gifts that Mooers gave as Christmas presents.

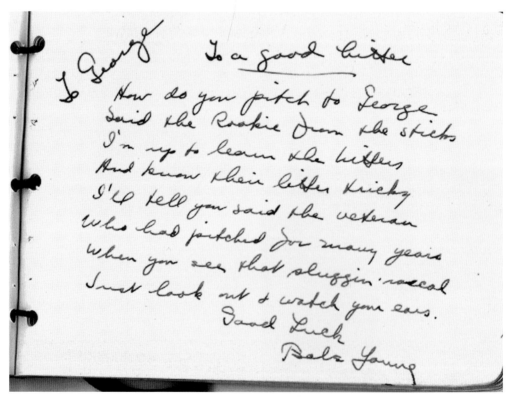

AUTOGRAPH BOOK, 1930s. A young Richmond Colts baseball fan's pride and joy, this quaint little autograph book offers tremendous power that belies its modest size. The leather-bound volume is chock-full of signatures of former Colt players dating to the years 1937 to 1939. The highlight of this autograph book would be the poem written by Colt slugger "Babe" Young, "To A Good Hitter."

RICHMOND VIRGINIANS LOCKER ROOM FOOTSTOOL. Some of the most innocuous objects could tell the most fascinating stories, if only they could talk. This footstool was salvaged from the locker room of old Parker Field. The stool possesses the orange and black colors of the Richmond clubs of 1954 and 1955.

HOME SCHEDULE PENCIL, 1956. This pencil features the home baseball schedule for the 1956 Richmond Virginians. Apparently these pencils were a giveaway at old Parker Field and were produced by Richbrau Brewing. The pencil is the bright orange color of the old Vees with print in black. The end of the pencil features a white plastic baseball.

RICHMOND VIRGINIANS SOUVENIR BUTTON, 1960s. This "bat and Dixie hat" Virginians logo pin-back button is believed to have been first sold at Parker Field's souvenir stands in the early 1960s. This logo was also used on the Richmond Vees scorecard programs for the 1961 to 1964 seasons. This concession piece was a clear indication of the wearer's sentiments as a Virginians baseball fan.

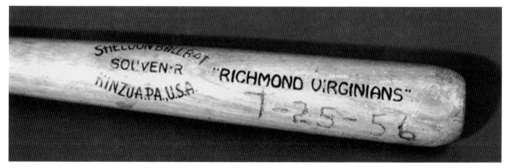

VIRGINIANS SOUVENIR MINI-BAT. Purchased from the souvenir stand located under the grandstands of old Parker Field, this 16-inch mini-bat has been dated by the owner July 25, 1956. The center brand on this bat states "Sheldon Ballbat Souvenir Kinzua, PA. U.S.A." with "Richmond Virginians" on the barrel end.

RICHMOND VIRGINIANS LETTER, 1956. This unique letter to the Louisville baseball club from Richmond general manager H. C. Krattenmaker discusses which team is responsible for player Dave Benedict's transportation home. It shows the new letterhead for the 1956 season and the signature (in blue ink) of general manager Krattenmaker.

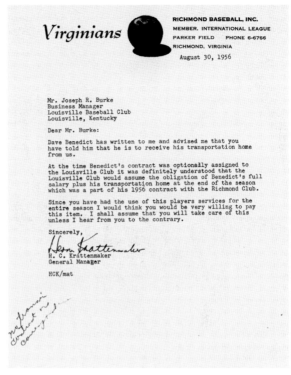

RICHMOND BASEBALL, INC.
MEMBER, INTERNATIONAL LEAGUE
PARKER FIELD PHONE 6-6766
RICHMOND, VIRGINIA

August 30, 1956

Mr. Joseph R. Burke
Business Manager
Louisville Baseball Club
Louisville, Kentucky

Dear Mr. Burke:

Dave Benedict has written to me and advised me that you have told him that he is to receive his transportation home from us.

At the time Benedict's contract was optionally assigned to the Louisville Club it was definitely understood that the Louisville Club would assume the obligation of Benedict's full salary plus his transportation home at the end of the season which was a part of his 1956 contract with the Richmond Club.

Since you have had the use of this players services for the entire season I would think you would be very willing to pay this item. I shall assume that you will take care of this unless I hear from you to the contrary.

Sincerely,

H. C. Krattenmaker
General Manager

HCK/mat

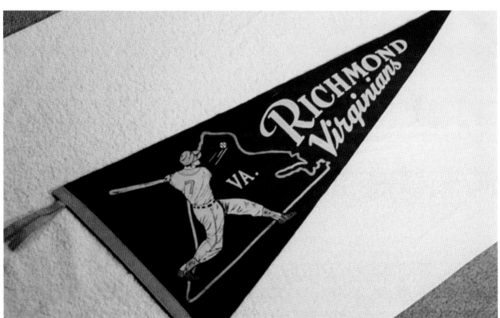

EARLY VIRGINIANS SOUVENIR PENNANT. A thoroughly regal souvenir pennant from Richmond's early days in the International League, this 29-inch, rich-black felt pennant features a caricature of a batter making contact with the sphere as if to propel it out of the state of Virginia. It must be noted that the caricature batter displays the mighty 7 on his back.

VIRGINIANS CUFF LINKS, 1958. These elegant cuff links feature a meticulously produced half-baseball with block lettering engraved "'58 Virginians." These high-quality, white-gold cuff links were customized by Swartzchild Brothers, Inc., of Richmond and tucked away in their designer pouch. The lore that encompasses this gift to the players is as varied as the number of players who wore the Richmond wool in 1958.

Authenticate with date and signature at bottom.

HOME CLUB BATTING ORDER

1 Johnston cf
2 Caro ss
3 Jaciuk 1st
4 Schell RF
5 Sanders 3rd
6 Chiti c
7 Windhorn LF
8 Graff 2nd
9 Bethel

DATE: 8/26/57 ___195_

Certified By (Signature)

VIRGINIANS LINE-UP CARD. The season of 1957 saw the Vees finish in the first division for the initial time. This relic of Richmond's past is the official line-up card that was placed on a nail in the home team's dugout. This game was played in the dog days of summer on August 26, 1957.

RICHMOND COLTS V FOR VICTORY PIN, 1945. Presented is a stunning example of what is perhaps the premier Richmond baseball team pin-back. This V for victory pin acknowledges America's war victory. One can only imagine purchasing one of these at the concessionaire at old Mooers Field, probably for 25¢.

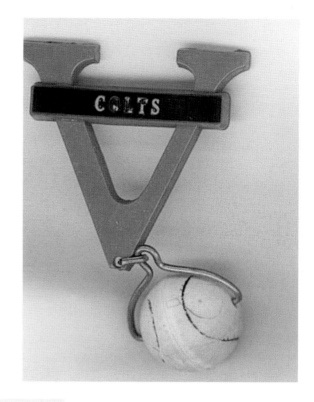

BURTSCHY PLAYER CONTRACT, 1956. Moe spent five years in the bigs as a right-handed pitcher for the Philadelphia and Kansas City A's. With the Vees in 1956, he compiled a 2-1 win-loss record with an impressive 2.57 ERA. Displayed here is his uniform player contract, dated June 20, 1956, with "the player to be paid at the rate of $1,000.00 (one thousand dollars) per month."

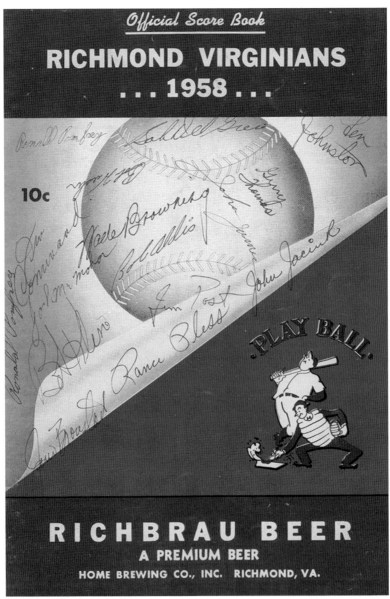

A Special Memory: 1958 Vees Scorebook. This Virginians home program was for a game that pitted the Richmond Vees against the Havana Sugar Kings. The scorebook features a new cover for the 1958 season, and contents include pictures of team shepherd Eddie Lopat, general manager H. C. Krattenmaker, and Pres. E. Claiborne Robins. There is a super aerial photograph of legendary Parker Field and numerous advertisements, including Nick Baronian's House of Steak, and Richbrau, "A Premium Beer." This program cover has the signatures of 14 Richmond Vee star players: Rance Pless, Jim Bronstad, John Jaciuk, Jim Post, Bob Kline, Bob Oldis, Jack McMahon, Jim Command, Wade Browning, Bob Wiesler, Bob Del Greco, John James, Gerry Thomas, and Len Johnston. The author was the 11-year-old fan who purchased this scorebook some 49 years ago.

RICHMOND VIRGINIANS LOGO COASTER. This plastic coaster featuring the Richmond Virginians "bat and Dixie hat" logo was sent to the author by former Vees pitcher Art Ceccarelli. Ceccarelli twirled for the locals from 1960 to 1962 and also pitched in the majors for the Cubs, A's, and Orioles.

JOIN THE VIRGINIANS IN CELEBRATING JUNE DAIRY MONTH

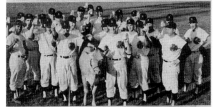

DAIRY NIGHT BASEBALL
Saturday, June 1, 1963, Parker Field
REGULAR $1.25 GENERAL ADMISSION TICKETS
THIS NIGHT ONLY — 50¢ PER PERSON
RICHMOND VS. COLUMBUS
VIRGINIANS JETS
Special pre-game entertainment 7:00 P. M. to game time (7:30 P. M.).
This coupon will admit you and your party to the unreserved grandstand for 50¢ per person. Reserved grandstand seats just 40¢ additional (if game is cancelled due to rain, Monday, June 10 will be observed as Dairy Night Baseball).
COURTESY OF YOUR LOCAL DAIRY INDUSTRY

DAIRY NIGHT BASEBALL, 1963. Pictured here is an advertising flyer for a game played at Parker Field on June 1, 1963. This game was part of the Virginians' celebration of Dairy Month in June, and fans were admitted for 50¢. Game featured a pregame milking contest between various players for each team. In this photograph, members of the 1963 Vees team hold up glasses of their drink of choice, milk.

PARKER FIELD BOOSTER PIN-BACK. Here is an extremely rare baseball pin-back button for the Parker Field boosters. Originating in 1954, these pin-backs were quite visible for the patrons pitching in to convert Parker Field to a multipurpose sports complex and to be the home of the newly acquired Richmond Virginians.

RICHMOND VIRGINIANS DIXIE PENNANT, 1960S. This felt pennant purchased at the concession stand run by "Mr. Concessionaire" Joe Baldacci features the new team logo, a baseball with bat and a Confederate hat. The pennant measures 27 inches by 9 inches and is a faded blue color from being permanently displayed for all to see.

EDDIE MOOERS'S SIGNED LETTER, 1953. This one-page, typewritten letter by Eddie Mooers is dated November 3, 1953. Addressed to George M. Trautman, president of the National Association of Baseball's Minor Leagues, the letter deals with Richmond player Joe Monterio, whose wife was having a baby. Mooers agreed to give the player an additional 30 percent of his salary if he was sold.

CELLULOID AND STRAW, OH WHAT A DOLL. This rare keepsake was snared from the concession stand of Parker Field during the 1954 season. Made of celluloid and stuffed with straw, this little ballplayer is sporting the Vees' orange color and affectionately wearing a Richmond Virginians pin-back. He appears to be patiently waiting his turn at bat.

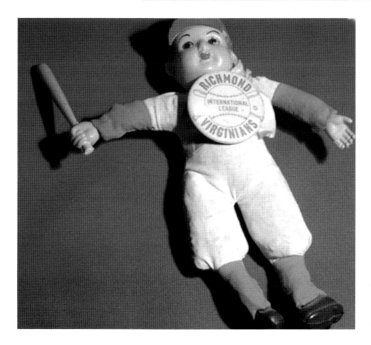

WORLD CHAMPIONS
New York

VS.
Richmond Virginians
MEMBERS OF INTERNATIONAL LEAGUE
PARKER FIELD
THURSDAY, APRIL 8, 1954 - 2 P.M.

PAY NO MORE **10¢** PAY NO MORE

RICHMOND VIRGINIANS VS. NEW YORK YANKEES PROGRAM SCORECARD, APRIL 8, 1954. This is a scorecard for the very first baseball game ever played at Parker Field. Some 16,000 fans showed up to watch the new entry into the International League, the Richmond Virginians, take on the world champion New York Yankees—quite a rare piece of Richmond baseball history.

EIGHTH INNING

VISITORS CLUBHOUSE

INTERNATIONAL LEAGUE READY

$25,000, a small amount to pay,
For the Richmond baseball franchise on a cold December day.
Richmond's Mr. Baseball, Eddie Mooers, was the seller,
Richmond Rebels football owner Harry Seibold the other fella.
With the International League knocking at the door,
And visions of AAA ball for the season of '54,
Find a park that's large enough and we'll surely seal the deal.
Let's renovate the old fairgrounds and call it Parker Field.
Seibold hard at work, his spirit never lost,
Went out and hired Luke Appling as Richmond's first field boss.
Still seeking baseball leaders, his choices were quite wise:
Seibold signed to coach that slugger Johnny Mize.
What shall we call our team, a name for all to please?
They started out Confederates, but quickly changed to Vees.
With the fans all excited and the players much the same,
We learn the Yankees are coming to play the Vees' first game.
16,000 fans in the stands to watch the two teams play—
No one could envision the rain we'd get on this historic day.
It would surely take more than rainfall to make this team feel blue,
But the mighty Yankees beat our Vees, the score was seven to two.

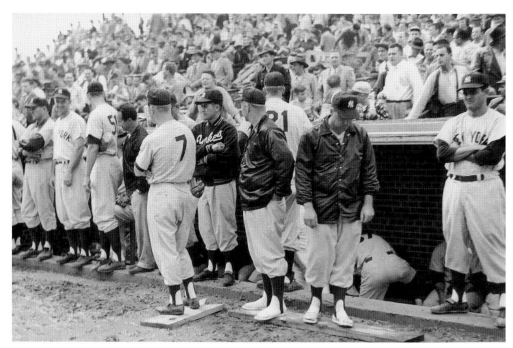

MANTLE PRACTICING SURFBOARDING? One of the most storied days in Richmond baseball history was this April 8, 1954, visit; no one could imagine the downpour that bestowed itself on Parker Field in the bottom of the first inning. With some 16,000 fans in the stands to see Richmond's cork-popper against the mighty world champion New York Yankees, a deluge of rain interrupted play for some 41 minutes. Here in front of the visitor's dugout is Mickey Mantle on his surfboard. Once play was able to resume, Yankee manager Casey Stengel, "37," stalks the visitor's dugout.

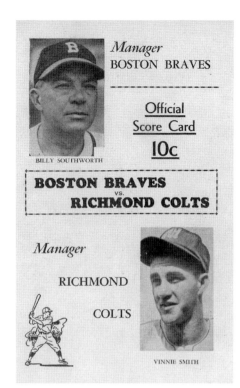

Manager
BOSTON BRAVES

Official
Score Card

10c

BILLY SOUTHWORTH

BOSTON BRAVES
vs.
RICHMOND COLTS

Manager

RICHMOND

COLTS

VINNIE SMITH

SPRING 1949: EDDIE "THE BRAT" STANKY AND THE BOSTON BRAVES VISIT MOOERS FIELD. Pictured below staring menacingly into the camera is Eddie "The Brat" Stanky, star second-sacker for the Boston Braves. Braves manager Billy Southworth brought his 1948 pennant winners to Mooers Field for an exhibition game prior to the start of the 1949 season. Over 9,000 fans packed Mooers Field to see the Colts lose to the Braves by a score of 12-7.

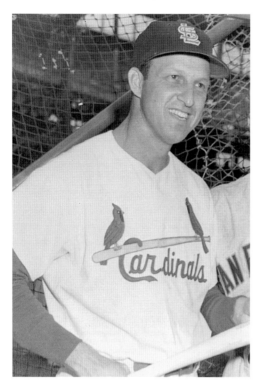

"STAN THE MAN" HOMERS, APRIL 10, 1952, MOOERS FIELD. On this date, Richmonders viewed a fabulous baseball game at Mooers Field pitting the Philadelphia Phillies against the St. Louis Cardinals. This scorecard is chock-full of stars the likes of "Granny" Hamner and Richie Ashburn for the Phillies and "Country" Slaughter and "Stan the Man" Musial for the Cards. Musial hit a round-tripper in the fifth inning; however, the Phillies still won 8-7, with hometown hero Hamner scoring two runs.

Souvenir Score Card

Philadelphia Phillies
VS.
St. Louis Cardinals

MOOERS' FIELD
Richmond, Virginia
Thursday, April 10th, 1952

APRIL 11, 1957: OL' PROFESSOR BRINGS HIS SLUGGERS TO TOWN. Shown below at spring training in St. Petersburg, Florida, is the contingent of Yankee sluggers who a few days later went to grace the grounds of beloved Parker Field. The Ol' Professor, Casey Stengel, is showing off his group of hitsmiths. These lumber legends did not intimidate the Richmond Vees, who prevailed against the Yankees, winning by a score of 6-5. Pictured from left to right are Casey Stengel, Woody Held, Billy Martin, Faye Thorneberry, Yogi Berra, Mickey Mantle, Hank Bauer, Bill Skowron, and Gil McDougald.

1957 EXHIBITION GAME

Richmond *Virginians* 6

vs

New York *Yankees* 5

●

PARKER FIELD
Richmond, Virginia

Thursday, April 11, 1957

Official
SCORE CARD
10c

SEARS ROEBUCK AND CO. **Sears is home plate in the Better Value League!**

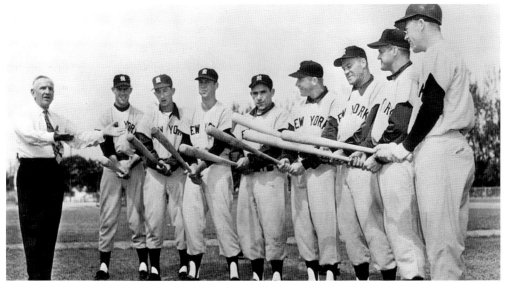

1958 EXHIBITION GAME

Richmond *Virginians* 11-5

vs

Boston *Red Sox* 7-1

PARKER FIELD
Richmond, Virginia

Sat. & Sun. April 12 & 13, 1957

Official
SCORE CARD
10c

APRIL 12 AND 13, 1958: TED GIVES HITTING CLINIC. On this historic weekend in the spring of 1958, the fans at Parker Field witnessed one of the most phenomenal hitting feats to ever occur in their fair city. On consecutive days, Ted Williams came to the plate as a pinch hitter and proceeded to deposit the pill over the right-field wall. At left is a rare scorecard from these historic games, in which Richmond was the victor in each contest.

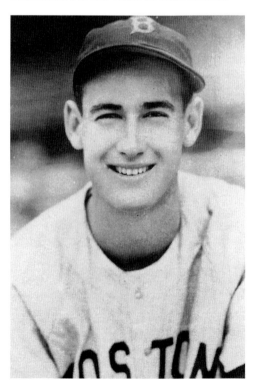

FIRST NIGHT BASEBALL IN RICHMOND, SEPTEMBER 1, 1931. As stated in the *Richmond Times-Dispatch*, "one of the most picturesque baseball teams in the country will play here tonight when the 'House of David' combine, headed by the famous major league mound ace, Grover Cleveland Alexander, plays the Colts at the stadium at 8 o'clock." These traveling ballplayers were known for their fantastic ability and for the whiskers that adorned their chins. This contest also marked a new innovation in baseball for Richmond fans, as it was the first night game ever played in the fair city. On this memorable evening, before 5,000 fans, the Richmond Colts defeated the "bearded wonders" by a score of 8-4.

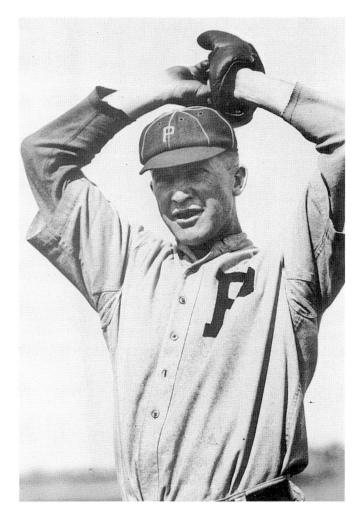

NITE BASEBALL
TONIGHT
AT STADIUM, 8:00 P. M.
HOUSE OF DAVID
With GROVER CLEVELAND ALEXANDER
World's Champion Pitcher
—vs.—
RICHMOND COLTS
ADMISSION, 50c **GRAND STAND, 75c**

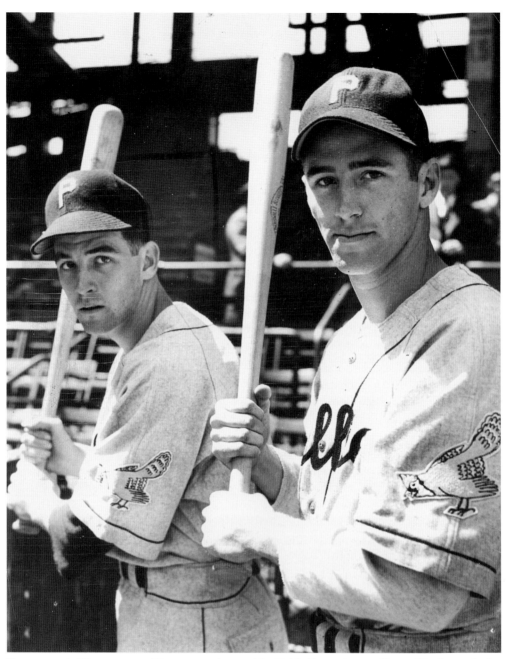

RICHMOND'S HAMMERING HAMNERS, APRIL 19, 1945. From the sandlots of Richmond, the homegrown Hamner brothers, Granny (left) and Garvin (right), stare intently into the camera's eye. They are posing at Ebbets Field, where they were making their debut as a brother duo with Philadelphia against Brooklyn. Of special note is the Bluejay emblem on their sleeves; Philadelphia took on this nickname for this 1945 season to help change their luck.

NINTH INNING

IN THE CAMERA'S EYE

A VIEW FROM THE SHUTTER

From Richmond's baseball past, the following we shall see,
Some of the characters from Richmond's baseball tree:
Soden's golden voice, doing interview at nite,
Or the slick fielding shortstop, Fritz, "The Mighty Mite,"
The sold-out stands at old Parker Field ,
Kasko's bachelor party, oh what a deal,
Dr. Parker and Mayor Haddock, 1954's opening day.
In 1955, we listen to what the IRS had to say,
Yogi on a plank, wet to his toes,
Red Ennis in uniform, striking a baseball pose,
Chuck Boone one of the catchers, Lou Martin calling strikes,
The Wee Momma of Lakeside, in her boys she delights,
Mayor Garber is a lefty, and the Thalhimers cake,
Clemente in the clubhouse, oh the plays he did make,
Appling peers at baseball plans, Stafford follows through,
Chapman's getting married, as most ballplayers do,
Gold baseballs were presented, dignitaries they did see,
Kutyna caught the ball from President Kennedy,
Handsome shortstop Klopf, from 1898,
The many fans at Mooers Field, through the turnstile gates,
Richmond's own Hamner Brothers, as quickly we pass by,
Were caught staring intently, in this, the camera's eye.

APRIL 20, 1954: DR. PARKER GETS AN ESCORT. Many pregame festivities, including the introduction of Dr. William H. Parker, for whom the ball field is named, preceded the curtain raiser for Richmond's entry into the International League. Here ballplayers from Thomas Jefferson and John Marshall High Schools escort Dr. Parker from the playing field. From left to right are John French, Jack Sullivan, Dr. Parker, Henry Bryant, and Earl Norman.

OPENING DAY CEREMONY, APRIL 1954. Richmond mayor Edward Haddock, flanked by Rochester manager Harry "The Hat" Walker and Richmond's shepherd Luke Appling, appears to be asking for help selecting the opening-day game ball. In the background are the recently erected bleachers on loan from the Washington baseball club.

GUS KLOPF, RICHMOND BLUEBIRDS, 1898.
Staring intently into the camera's eye is this handsome infielder, who was released from the Galveston ball club to Richmond in January 1898. Gus helped lead the Bluebirds to the Atlantic League pennant in 1898.

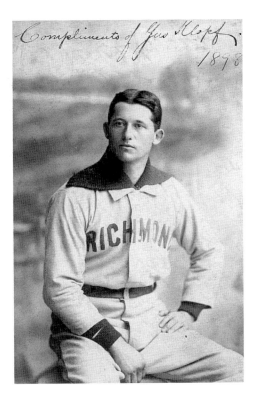

FRANK SODEN RICHMOND'S GOLDEN VOICE OF SPORT. Frank Soden was the play-by-play announcer for the first AAA baseball game ever played in Richmond featuring the Richmond Virginians in April 1954. Seen here in front of the first-base dugout of old Parker Field, Frank is interviewing visitor Kerby Farrell. Truly an icon of sports broadcasting, Frank is the epitome of broadcasting excellence. Richmond sports fans have been blessed to have such a high-caliber individual, for Soden has been an inspiration to everyone who has had the pleasure of his presence.

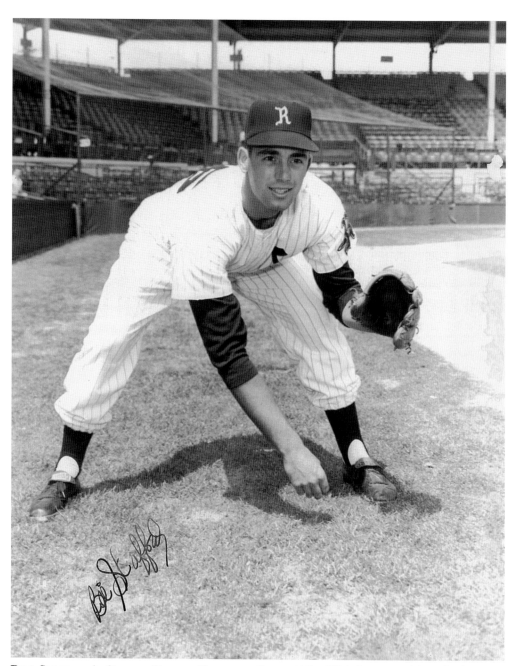

BILL STAFFORD'S CLASSIC FOLLOW-THROUGH POSE, 1959. With his eternal boyish glow, Bill poses on the sidelines of Parker Field in his classic bent-back follow-through stance during the 1959 season. He pitched briefly for the Vees in 1957 and returned for the 1959 and 1960 seasons. During 1960, Bill became dominant as a Richmond moundsman, winning 11 games and possessing a 2.06 ERA. Bill's accomplishments with the Vees earned him a shot in the bigs with the New York Yankees. While taking the slab for the Yankees, he compiled 43 victories in six seasons with a 3.52 ERA. Bill also appeared in three World Series with one win and an impressive 2.08 ERA.

YOGI WALKS THE PLANK, APRIL 8, 1954. Seen here are four of Richmond's finest, keeping the order outside of the Yankees' dugout. The preceding rainstorm had left the field basically unplayable, but the groundsmen whipped the field into playable condition. Yankee catcher Yogi Berra walks on a plank to stay out of the mud, with outfielder Hank Bauer close behind.

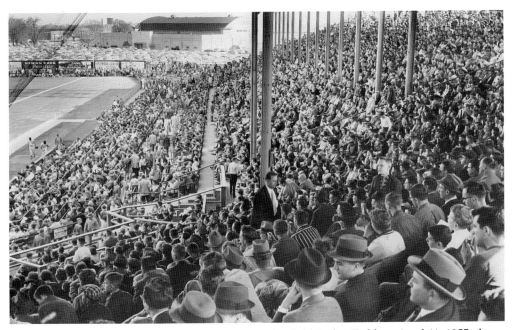

STANDING ROOM ONLY. This view from the stands of old Parker Field on April 11, 1957, shows an overflow crowd to watch the Richmond Vees' 6-5 victory over the New York Yankees in this preseason exhibition tilt. Right field to center field is shown roped off to handle the abundance of fans.

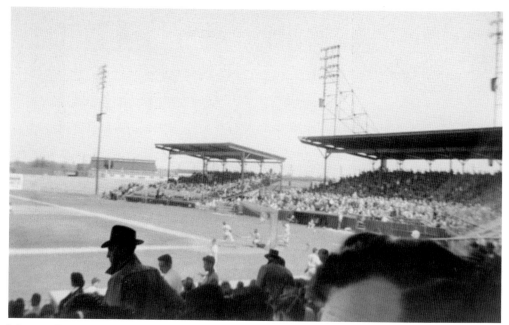

MOOERS FIELD'S "COLORED" GRANDSTAND. This stunning action shot at old Mooers Field shows a packed house with a super view of the black grandstands, whose seats were listed at a cost of $1,330.17 on a May 1949 entry in the Colts' ledger book.

NOVEMBER 14, 1955: A SAD DAY FOR RICHMOND BASEBALL. Seen here on the infield garden of beloved Parker Field is Jack Overby of the Internal Revenue Service, who turned auctioneer to sell the Richmond Virginians baseball club of the class AAA International League to satisfy tax liens totaling more than $79,000. A Richmond syndicate purchased the club franchise, equipment, and player contracts for $20,000.

THE WEE MOMMA. Mrs. Tommy Galloway cordially opened her home on Hilliard Road to Richmond Vee ballplayers who needed a place to stay when not on road trips. Beginning in 1954 with Eddie Kasko, the list grew with the likes of John James, Bob Wiesler, and Bill Stafford. Whether it was picnics on the lawn, cold drinks on the porch, or singing at the piano, the ever-gracious "Wee Momma" was the perfect hostess, loved and adored by all her boys, who found their home away from home. Wee Momma is pictured here with, from left to right, Bill Stafford, Bob Wiesler, Ed Dick, and John James.

WHO'S THAT UMPIRE? None other than newly named general manager for the 1964 Richmond Vees Lou Martin is shown here in pregame antics, calling a third strike on Miss Richmond. Lou went on to serve in the major leagues in the same capacity with the Montreal Expos. He still resides in the Richmond area, where his fans can find him on any given evening officiating basketball games or by day on the golf course.

GOLD BASEBALLS AND A THANK-YOU, APRIL 14, 1959. Soon after the final out of the 1958 season, the New York Yankees entered in negotiations to purchase the Richmond Vees. The sale was consummated early in 1959, and pictured here on April 14, 1959, the Virginians' new management paid tribute to the former owners and directors of Richmond Baseball, Inc. Gold baseball mementoes were presented to the group. Pictured from left to right are Fritz Sitterding Jr., E. Claiborne Robins, Milton Markel, H. J. Berstein, Dan J. Friedman, D. Andrew Welch, Dr. E. E. Haddock, Dave E. Satterfield III, Lucian W. Bingham, and L. L. Rustad.

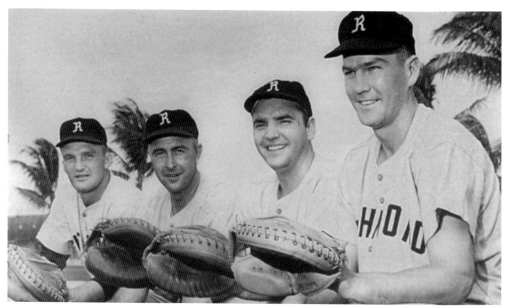

SPRING TRAINING, 1961: DONNING THE TOOLS OF IGNORANCE. Pictured here during spring training in 1961 at Fort Lauderdale, Florida, are four aspiring catchers for the Richmond Vees. With their hopes still alive for making the team are, from left to right, Chuck Boone, Billy Shantz, Rich Windle, and Chuck Buheller. (From the collection of George Tinker.)

EDDIE KASKO, YOU'VE HAD IT. This snapshot of Eddie Kasko was taken in January 1958 at his bachelor party, given by Marx Mitteldorfer Sr. Eddie, the former Richmond Vees shortstop, was now covering the infield garden for the St. Louis Cardinals. Seen here with host Mitteldorfer, Eddie laughs with Cardinal teammates Joe Cunningham (left) and Don Blasingame (right).

WHERE ARE THE LADIES? Pictured above are the attendees at Eddie's bachelor party at the home of Marx Mitteldorfer Sr. on Kingcrest Parkway. Seated from left to right are host Marx Sr., Don Blasingame, Joe Cunningham, Eddie Kasko, and Frank Smith. Standing from left to right are Bobby Patterson, Shelly Rolph, Frank Messer, Marx Mitteldorfer Jr., Andy McCutcheon, Al Lehman, Gil Johnson, Ralph Dunbrower, Bob Heibinect, Ben Freeman, Lawrence Leonard, Chaucey Durden, Joe Barker, and C. M. Castle.

RICHMOND MAYOR GARBER THROWS OUT FIRST PITCH. Richmond mayor Henry Garber throws out the first pitch on opening day of the 1956 season. This starboard slinger appears to be gripping a four-seam fastball. His wife, seated to his left, smiles with approval.

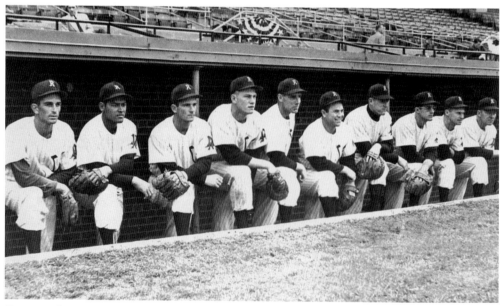

OPENING-DAY LINEUP, 1956 RICHMOND VIRGINIANS. Posing on the dugout steps of Parker Field is the opening-day lineup for the 1956 season. The Vees ended the season in fifth place, with significant lineup changes by season's end. Lined up in the order in which they appeared at the plate are, from left to right, Lennie Johnston, Pablo Rivera, Buddy Carter, Frank Leja, Al Van Alstyne, Vic Marasco, Moe Thacker, Al Facchini, Jim Post, and manager Eddie Lopat.

NINTH INNING: IN THE CAMERA'S EYE

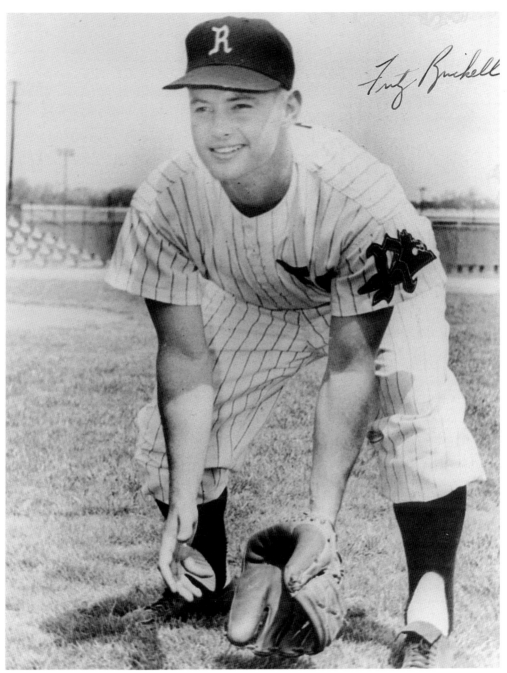

"The Mighty Mite" Fritz Brickell, 1959. Pictured in his pinstriped Richmond Vees uniform, Fritz poses in his fielding position. Upon Fritz's arrival at Parker Field in 1959, he quickly became a fan favorite with his slick fielding and potent bat. In his two seasons in Richmond, 1959 and 1960, Fritz hit a respectable .247 and .258. His major-league career included stints with the New York Yankees in 1958 and 1959 and the Los Angeles Angels in 1961. Fritz's life would tragically end in 1965 at the youthful age of 30, but not before he left his mark in the sands of old Parker Field.

BABE YOUNG, 1949. Former Richmond Colts first baseman (1937–1938) and war-club warrior Babe Young appears to be teaching the art of throwing the knuckleball. In this photograph from February 1949, he demonstrates how to grip the ball to his young son, Robert, while daughter Susan watches attentively. Babe had just recently been signed by the New York Yankees to play first base after a splendid eight-year stint in the National League.

PRES. JOHN F. KENNEDY AT WASHINGTON SENATORS ON OPENING DAY, 1962. Former Richmond Vees pitcher Marty Kutyna, seen here with Pres. John F. Kennedy, caught the first ball of the season, which was thrown out by the president. Kutyna, who toed the rubber for Richmond in 1957, posted 10 wins and helped lead the Vees to their first division playoff spot in the International League.

MANAGER APPLING REVIEWS BALLPARK PROPOSAL, JANUARY 14, 1954. On a brief visit, Richmond's newly hired Triple-A manager Luke Appling looks over plans for proposed renovations to Parker Field. Appling apparently likes what he sees, for he is wearing a broad smile while pointing to the third-base dugout.

AND THE CAKE WAS BY THALHIMERS. The general of the fund-raising drive to convert Parker Field to a multipurpose sports complex, Ed Phillips is presiding over one of the fund-raising dinners in the 1954 preseason. Seated to his right is Richmond mayor Haddock. The chef from Hotel Richmond is preparing to cut the cake, a replica of Parker Field prepared by Thalhimers.

"RED" ENNIS, RICHMOND COLTS, 1948–1953. Pictured here on the sidelines of Mooers Field, adorned in his Richmond Colts warm-up jacket, is Red Ennis. Red was one workhorse of a ballplayer during his six-year stint with the Colts. Taking his customary post on the mound for Richmond, he notched 72 wins during his tenure as a Colt.

MARY ELIZABETH COULD NOT TAME HIM EITHER, JULY 6, 1931. Future Richmond Colt star player and manager Ben Chapman ties the knot with former Mary Elizabeth Payne. The star left fielder for the New York Yankees is seen here leaving the little church around the corner after their marriage. Known for his hot temper, Ben—while managing the Richmond Colts in 1942—struck an umpire during an altercation and was banned from baseball for the 1943 season.

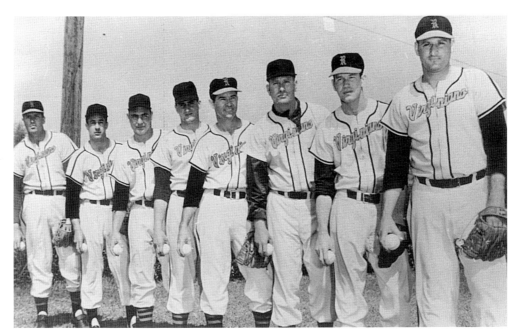

PROTECTORS OF THE SPHERE, 1955. The powers that be assembled this contingent of talented hurlers in hopes they would annihilate the opposition, but there were few proficient outings, and the staff ended the 1955 season with a total of 58 victories. Pictured here from left to right are Bill Voiselle, Wimpy Nardella, Zack Monroe, Guy Grasso, Tommy Fine, Sonny Dixon, Ken Beardslee, and Ivan Abromowitz.

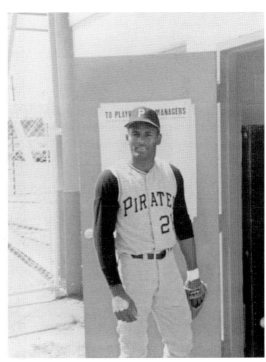

CLEMENTE AT CLUBHOUSE DOOR, APRIL 6, 1968. Here is a fantastic snapshot of Pittsburgh's star right fielder Roberto Clemente as he pauses for the photographer before entering the visitors clubhouse. The Pirates stopped in Richmond to play the Yankees in two exhibition games at Parker Field on April 6 and 7, 1968. One of the greatest right fielders to ever play the game, Roberto met an untimely death in a plane crash on New Year's Eve, 1972.

EXTRA INNINGS

THE WAY WE WERE

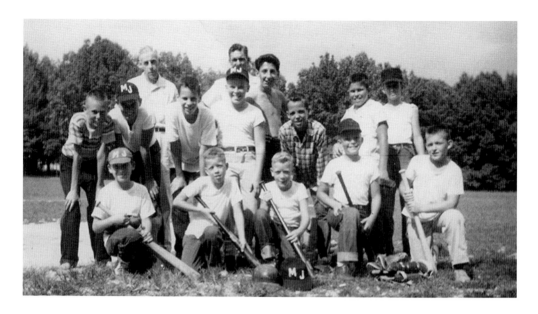

1957 MECHANICSVILLE JETS

Summer of '57, never heard of a mall
Simply rode our bikes to Sledd Field to play some baseball.
Didn't have real uniforms—jeans, T-shirt, and hat—
Seldom saw a new baseball, most of the bats they had a crack,
No dugouts or fences, when our field was all done,
Wood planks on block, and chalk dust, that was when baseball was fun.
Mr. Dart and Mr. Hicks, our coaches would be,
Got us real games with Glen Allen and Glen Lea.
With Wooddy behind the plate, and Rich on the mound,
Simpkins and Christy, the two fastest in our town.
King as our shortstop, Hicks held down third,
Never any bickering or discouraging word.
Dart on second, Zagos and Mitchell chasing flies,
Kelly and Jones two pitchers, we did rely.
Beasley at any position, he could play them indeed;
Smith our first baseman, his glove we did need.
Not exactly the New York Yankees, or even the Mets,
But, oh what a memory, the Mechanicsville Jets.

TO THE SHOWERS

ABOUT THE AUTHOR

Ron Pomfrey has been researching the history of Richmond baseball and been an avid collector of sports memorabilia for the past 30 years. The treasures and knowledge that he has acquired and his true passion for the game are what has inspired him to write this book. Ron shares this information by giving presentations to local civic groups on the legends of Richmond baseball and the artifacts associated with Richmond's baseball past. Some of his artifacts were recently on display at the Black History Museum in Richmond. He is always searching for additional memorabilia and is always happy to share his knowledge and expertise with fans and collectors. Ron's future books that are in the planning stages include *The Richmond Braves* and *Football in Richmond.*

DISCOVER THOUSANDS OF LOCAL HISTORY BOOKS FEATURING MILLIONS OF VINTAGE IMAGES

Arcadia Publishing, the leading local history publisher in the United States, is committed to making history accessible and meaningful through publishing books that celebrate and preserve the heritage of America's people and places.

Find more books like this at
www.arcadiapublishing.com

Search for your hometown history, your old stomping grounds, and even your favorite sports team.